# THE COMPLETE GUIDE TO
# PAINTING PICTURES
# FROM PHOTOS

# THE COMPLETE GUIDE TO
# PAINTING PICTURES
# FROM PHOTOS

## SUSIE HODGE

D&C
David and Charles

A DAVID & CHARLES BOOK
Copyright © David & Charles Limited 2008

David & Charles is an F+W Publications Inc. company
4700 East Galbraith Road
Cincinnati, OH 45236

First published in the UK in 2008
First published in the US in 2008

Text and illustrations copyright © Susie Hodge 2008

A catalogue record for this book is available from the British Library.

ISBN-13: 978-0-7153-2800-2 wire-o
ISBN-10: 0-7153-2800-X wire-o

ISBN-13: 978-0-7153-2801-9 paperback
ISBN-10: 0-7153-2801-8 paperback

Printed in China by Shenzhen Donnelley Printing Co Ltd
for David & Charles
Brunel House, Newton Abbot, Devon

Senior Commissioning Editor: Freya Dangerfield
Editorial Manager: Emily Pitcher
Desk Editor: Bethany Dymond
Art Editors: Martin Smith and Sarah Underhill
Designer: Emma Sandquest
Text Editors: Diana Vowles, Nicola Hodgson and Betsy Hosegood
Production Controller: Kelly Smith
Photographer: Kim Sayer

Visit our website at www.davidandcharles.co.uk

David & Charles books are available from all good bookshops;
alternatively you can contact our Orderline on 0870 9908222 or write
to us at FREEPOST EX2 110, D&C Direct, Newton Abbot, TQ12 4ZZ
(no stamp required UK only); US customers call 800-289-0963 and
Canadian customers call 800-840-5220.

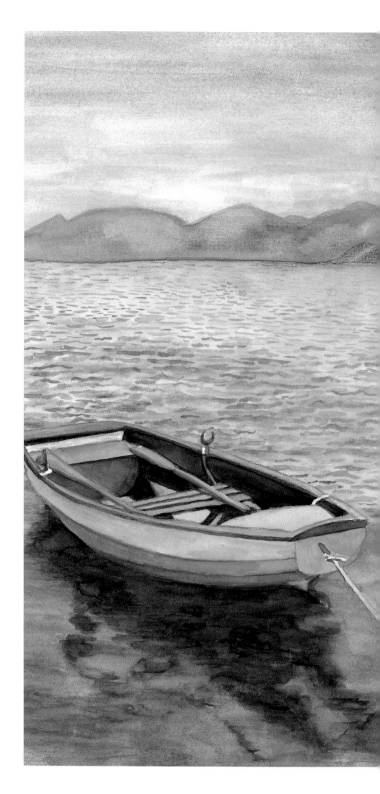

# Contents

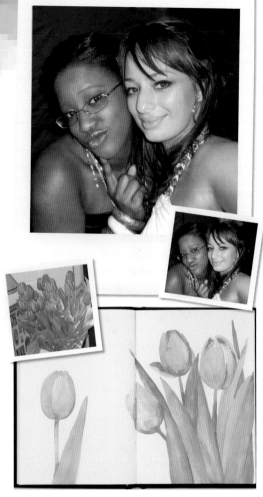

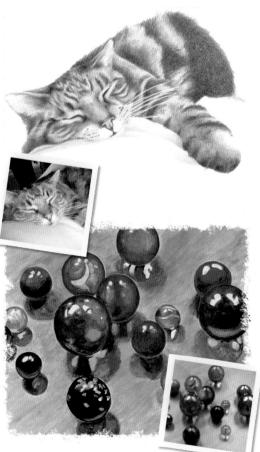

# Introduction

Many fine painters, both past and present, have taken advantage of the benefits photography has to offer. As a means of providing reference material it is invaluable, especially for a fleeting scene that can never be revisited; the movement of animals and human figures can be recorded, for careful study; and holiday photographs can provide a generous source of paintings of new landscapes and cultures when it hasn't been practical to travel with a painting kit. And in these digital days, photographs can be enlarged on the computer screen, inspiring ideas of compositions, crops and abstract approaches that can be examined and judged worthy or not of trying out in paint.

## Photography in art

While it has become more common in recent times, there's nothing new about artists using the camera as a reference. Over 2,000 years ago, Aristotle wrote about the camera obscura and by the early 1500s artists were using it as a drawing instrument. It is believed by some that the 17th-century Dutch masters, including Vermeer, achieved their incredible accuracy and detail by means of the camera obscura and it is well established that in the 18th century Canaletto and Joshua Reynolds made use of it.

The camera obscura worked on the optical principle that light travelling through a small hole into a dark room projected an inverted image onto the facing wall; the effect could be achieved by simply piercing a hole in a piece of fabric. But while pinhole cameras, and later lenses, were developed on this principle, it wasn't until the mid-19th century, when a means of making a print was invented, that artists were able to use photography as we understand it as a way to develop their work.

Famously, artists had always depicted horses as galloping like rocking horses, lifting all their legs from the ground at once, until in 1878 Eadweard Muybridge took a series of photographs that showed their gait at varying speeds. After this, artists depicted galloping horses realistically, and the impact that the new technique of photography could have on the art world became evident. Delacroix, Corot, Courbet, Degas, Cézanne, Toulouse-Lautrec and Picasso are just a few of the early artists who worked with photographs, using them to bring vigour and dynamism to their compositions and to help them represent movement, perspective and tone with added perception.

## Photography today

In spite of its long history, you may have heard some artists express disapproval of the use of photography as a basis for paintings. It's true that slavishly copying a photograph is not a creative way to work and will give a flat, static result. However, as long as you beware of the pitfalls, the advantages you will gain will be considerable.

Photography is an excellent means of gathering a lot of information in a short time, and the very act of taking the photographs will often help you think about composition and focus on what you really want your subject to be. You can shoot a series of photos on the same subject to help you understand more about your theme and record highly detailed subjects, enabling you to save the decision-making about what you want to include and what you can safely lose until you are in the comfort of your own home – instant decisions can be tempting when you are painting outdoors in challenging weather and they aren't always the best ones!

Used as sketches, photos can help you determine colours and tones and confirm perspective and foreshortening. They are brilliant at capturing a moment in time – a particular light on a landscape, a pet that won't sit still, a busy street scene and so on. Sometimes, looking at a photo afterwards, you can even see something interesting, quirky or compositionally valuable that you failed to spot at the time. If you've never tried painting from photographs before, this book will introduce you to a new way of working that will enrich your experience immeasurably.

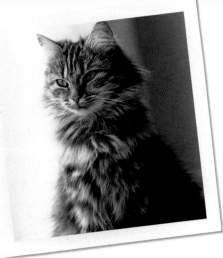

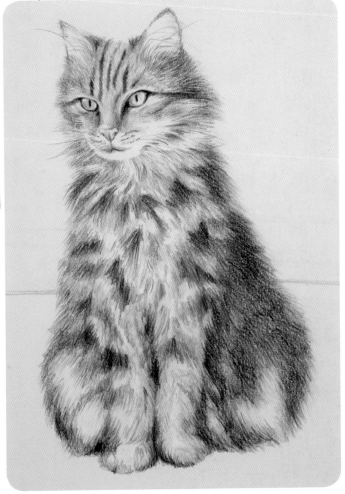

Although cats are capable of sitting still for hours, they always get up and walk off if you try to draw or paint them. A photo is invaluable for catching an animal's expression and provides an instant reference for complicated markings. This project is shown step-by-step on pages 113–117.

## Points to remember

• Don't try to copy a photo stroke for stroke – try to make the painting say more or express a different feeling.

• Ideally, work from photos that you have taken yourself – that way, the composition is entirely yours, and you will have a fuller understanding of the subject. The photos will recall the sense of place or character to help you depict the subject in as full a way as possible.

• Be aware that photos can compress or distort and they can also give an incorrect rendering of colour. Use your judgment rather than relying on the photo, and if you have the time, make a few sketches and add some colour references to help you, either by describing the colours in note form or by using coloured pencils or watercolour.

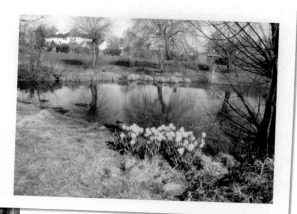

It isn't always convenient to stop and sketch or paint when you see a likely view, so keep your camera with you to take a few snaps for later use. When you come to do the painting remember that you can improve on nature – I 'lost' the grass clippings here and tidied up the buildings in the distance. (See also page 68.)

# How to use this book

This book is intended to help you to use photographs as references or starting points for paintings. It will help you avoid problems that might occur when using photos and show you how to maximize the benefits of using a camera, acting as both a practical guide and as a source of ideas. To start with you need a suitable camera (see page 12) and should learn how to use it (page 18) and how to store your photographs properly (page 20). With digital images it can be very liberating to explore possibilities of colour, design and composition on the computer (pages 24–29), but always keep copies of your originals, perhaps making a photographic sketchbook that includes the originals as well as a number of edited versions (page 30).

Of course, understanding how to take and use photographs is only the start. You will need to think about all the usual concerns that should occupy the artist: medium, composition, light, tone, movement and so on. All these are covered in this book, and you'll find some invaluable step-by-step projects too (pages 78–125), which should help you bring everything together. Add your own style and individuality to paintings from your photos and you can inject your work with something quite special.

## Simple techniques

Photographic and computer techniques covered in the book are simple and easy to understand.

## Tips

There are three types of tips, relating to photography, the computer and painting. Each is labelled with a particular motif so you can easily identify what it is about. For instance, tips on photography will be flagged with the camera motif (top); if you need all the help you can get manipulating photographs on the computer, look out for the computer mouse mat (centre); red brushstrokes (bottom) signify a tip about painting.

*camera tip*

*computer tip*

*painting tip*

## Topics

The important topics that an artist needs to learn about are all covered, including composition, dealing with light, tone, colour and movement.

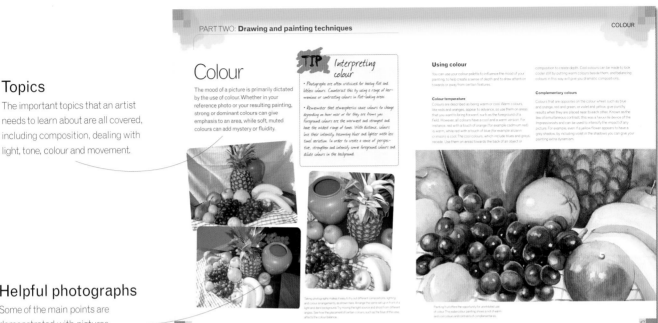

## Helpful photographs

Some of the main points are demonstrated with pictures.

## Materials list

A full materials list including brushes and paints is given, enabling you to follow the artist's work using the same reference photograph and with the step-by-step pictures to guide you.

## Specific subjects

Six extensive step-by-step projects are included, covering favourite subjects: landscapes (page 80), flowers and foliage (page 88), still life (page 94), buildings (page 102), animals (page 110) and portraits (page 118). Each demonstration includes a copy of the original reference photograph(s) so you can see how the image has been developed in paint.

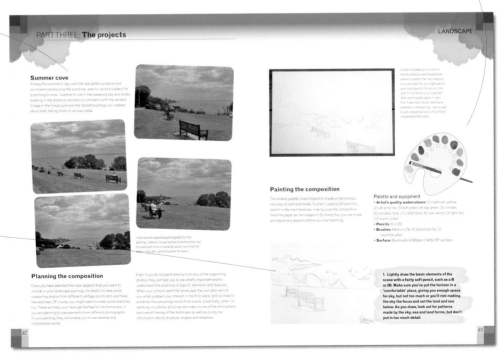

## Large images

Large step-by-step illustrations enable you to see exactly what the artist is doing, and full instructions help you master the techniques.

# Cameras and computers

Just like a pencil or any other piece of art equipment, your camera is a tool that will help you to express your creativity. Fortunately, it is not necessary to be an experienced photographer to obtain the kind of source material you need in order to produce great paintings – you just need to know what to look for and how to record it, and if you have a modern digital camera this is now easier to accomplish to a satisfactory standard than ever before. This part of the book gives some basic information and advice about cameras and related equipment, including computers and software programs. Whether you are already experienced with a camera or a complete novice, it will help you to make the most of the photos you take, which in turn should lead to better paintings.

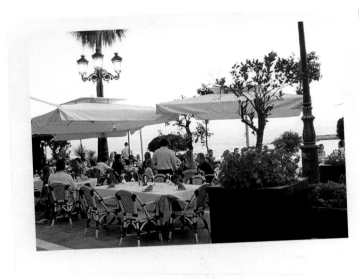

If an image that looked great 'in the flesh' turns out a bit dark, with today's easy-to-use editing equipment it is easy to brighten and freshen up a dark photo or deepen an overexposed picture.

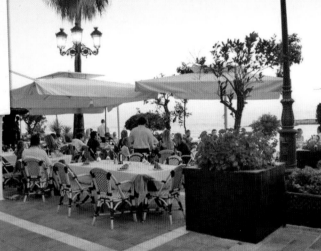

Try experimenting with the wide range of image-editing software available to get the most from your photographs. It can be easy to add different crops and tints, sharpen colours and tones and even clone out distracting items, such as these wooden posts.

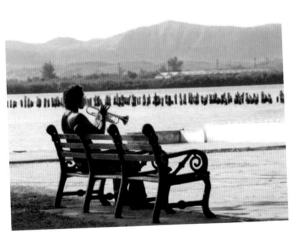

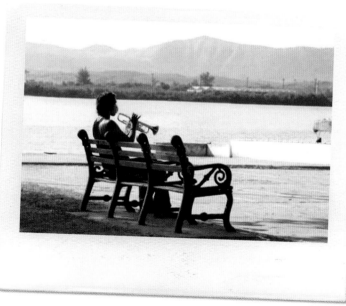

# Choosing your camera

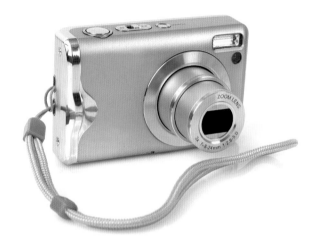

If you haven't already got a camera, chances are that your new purchase will be a digital one – they account for over 90 per cent of cameras sold today.

This is because digital photography offers many advantages over film photography – practically, creatively and economically. You don't need a computer to use one because you can get prints by taking your memory card to a processing lab in exactly the same way as with a film, though sometimes a lot quicker. However, if a digital camera doesn't appeal to you or if you have a film camera already, that's fine – you don't have to go digital.

A good compact camera has a zoom lens, built-in flash and plenty of automatic functions to make photography easy.

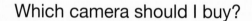

## Which camera should I buy?

Before you buy a new camera, consider the following questions:

• What is my budget? You can spend just about any amount you can think of on a camera. Remember that your purpose is to take reference photographs for your paintings. There is no need to go overboard on cost.

• What are my favourite subjects for painting? If you like to paint flowers or insects you will want a camera with a macro capability, which many zoom lenses offer. If you want to paint boats, beach scenes or sea life, a waterproof or at least splash-proof camera is essential.

• Will I want any indoor or low-light shots? If you will, you may need a good flash or the ability to attach one, and you may wish to consider buying a tripod to hold the camera steady for slow shots.

• Do I want a camera with lots of options or just something to point and shoot? If ease of use is paramount, a compact camera is for you.

• Are size and weight important? If you are out and about with an easel or art board, paper, paints and so on, how much extra weight can you carry? Consider buying an inexpensive lightweight camera or camera phone that you can take with you everywhere, and a larger, more powerful camera for other occasions.

## Compact cameras

These are sufficient for most purposes and some have some very handy features. Most have a fixed focal lens length of around 35mm while some also have a zoom lens. Digital cameras with a resolution of 3MP (megapixels) or higher are fine for prints of about 15 x 10cm (6 x 4in).

### Pros

• They are small and easily carried in a pocket or bag.
• They have point and shoot capabilities with automatic settings for specific subjects such as portrait, landscape and night view.
• Most digital versions have an integral flash set to operate automatically when needed.
• Some have a zoom lens, which is ideal for portraits or close-ups of flowers.

### Cons

• Altering depth of field or taking very close-up images is usually not possible.
• You generally can't attach different lenses, such as macro.
• When taking a picture you look at the subject through a viewfinder slightly above and usually to one side of the lens, which doesn't show you exactly what the lens sees. However, this is usually only an issue with close-up and if you have a digital camera you can view the image through the screen.

# SLR cameras

These are more professional cameras that enable you to use different lenses for different purposes, allowing you to compose images with greater flexibility than with compact cameras. SLR means 'single lens reflex' and the digital versions are DSLRs.

## Pros

- The ability to use specialized lenses means that you can take macro or super close-up photographs or very wide-angle shots, for example.
- Many have an automatic mode, which sets the correct shutter speed and aperture for the existing light conditions, but you can also change the settings manually, enabling you to blur backgrounds, for example.
- Quality is often better than with a compact camera, as most SLRs and DSLRs are built to a higher specification. DSLRs have larger sensors than digital compact cameras, meaning that a DSLR of 5MP will produce better images than a compact of 5MP.
- When you look in the viewfinder you will see exactly what the lens sees, so precise composition is possible.

## Cons

- Cost – usually a lot higher than for compact cameras.
- SLR and DSLR cameras are both heavier and bulkier than other cameras.

# Phone cameras

Modern mobile phone cameras can be really quite good – 5MP, for example – though they are usually not as versatile as standard cameras. The rougher quality of images taken with a camera phone can imply snatched shots, evoking an event or place.

## Pros

- They are highly portable.
- Once you have learnt how to take a picture the first time they are simple to use.
- Taking informal pictures of people and places is made easy.

## Cons

- The quality of images is not usually as good as with a camera.
- It takes phone cameras a while to recover from shooting, so trying to take lots of shots quickly presents its own problem.
- It isn't as easy to print from a phone as from a camera.

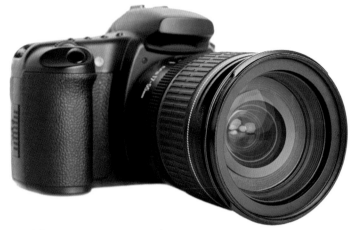

With a DSLR you usually have the option of being able to change lenses. You may have a built-in flash or this might be an extra.

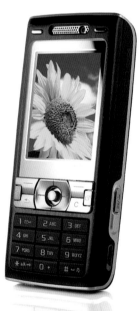

Once you get to grips with the workings of your mobile phone, taking pictures is easy, though the speed and quality aren't usually as good as with a camera.

 **tip** Focus on the zoom

If you want a compact camera with a zoom function, check whether the one you are considering has an optical zoom or a digital zoom. An optical zoom is what you would be accustomed to in a film camera. It uses the lens to magnify the view in the same way as binoculars. A digital zoom basically crops and enlarges the section of the image that you are interested in, just as you might do yourself on a computer. This means that it hasn't gathered any more detail than the standard picture, so the quality is lower.

# Additional equipment

In addition to a few camera accessories, if you are going to take the digital route and print your own pictures you'll need a computer, the right software and a printer. On the plus side, you'll be able to print your pictures almost instantly without needing to send them off to a processing lab.

### tip
## Protect your lens

If your lens accepts filters, it is well worth buying a UV filter. This cuts out haze but won't otherwise affect your pictures, nor will it alter exposure metering. Its most useful function is that it will protect your valuable camera lens – if you drop the camera and scratch the filter, it is much cheaper to replace that than a damaged lens.

## Camera accessories

A camera bag is essential, even for inexpensive cameras as these are less robust than better-quality ones. Digital cameras require special bags with soft linings to protect the screen, or you can buy camera pouches for compact cameras that will slip in a large pocket or daypack.

If you have an SLR or other camera that accepts different lenses, you may wish to buy an extra lens or two. For landscapes, consider adding a wide-angle lens, which gives a wider than usual view, ideal for panoramics. If you favour portraits, consider a small zoom so that you can frame faces as you wish and photograph from further back so that the subject doesn't feel too self-conscious. If you like to paint flowers or insects, consider a macro lens, which lets you get really close.

Filters, which attach over the lens, can help to produce more realistic or heightened colours or fun optical effects. Two of the most effective are the 81A warm-up filter, which cuts down the UV light and adds a little warmth, and the polarizing filter, which reduces reflections in shiny surfaces and water and can help darken the blue of the sky, depending on the position of the sun (this filter will normally come with instructions and a diagram to show you how to use it). If you have a computer and photo-editing software, you won't need most of the fancy filters because their effects can be achieved digitally.

A lens hood will allow you to shoot facing the sun without flare spoiling your picture and will shield the lens glass or filter from driving rain.

Finally, a tripod is bulky and heavy to carry around, but it will steady the camera if you are photographing in low light, either indoors or at sunset or sunrise, for example.

## Computer

Most people who are interested in editing digital photographs already have a computer at home. It doesn't matter if it is a laptop or a desktop, old (which in computing terms means about five years or more) or new, but it does help if it has plenty of memory (see below) and a good screen. You may even have a mini computer, and that's fine too, provided that it meets the criteria listed below.

If you have a computer, the chances are that it runs on Windows because 95 per cent of personal computer (PC) owners use Windows, while only 5 per cent use Apple Macintosh (Mac). Macs are usually more expensive – as is their software – but they come with a certain amount of software already supplied, including a good package for digital imaging, while Windows PCs may be cheaper, but don't always have software provided. Any software you buy must be compatible with your computer: you can't usually run Mac software on a Windows system and vice versa, though TIFF, JPG and PDF files are interchangeable.

Ideally, your computer should have the following features:

• At least 80 gigabytes of disk storage space – photos take up a lot of space, and the better your camera, the bigger the file sizes are likely to be.

• Plenty of RAM (Random Access Memory). The more RAM you have, the faster your computer works. It pays to have as much RAM on your PC as you can, and you can often get a better deal if you purchase extra RAM at the same time as you buy your computer.

• A good processor. If you haven't already bought your computer, get one with the fastest processor you can afford.

A laptop is ideal for anyone who doesn't use the computer a lot because it doesn't take up much space and is often the most economical option. It has a built-in screen and usually a CD/DVD drive too. Laptops have built-in rechargeable batteries so you can use them on trains or planes, for example, or work in any room of the house. Their drawbacks are that they don't tend to be as powerful as desktops (though this is changing fast), and if one element breaks, such as the screen, you may have to replace the whole laptop.

An iMac takes up less space than a desktop and looks wonderful, with just a keyboard, mouse and thin widescreen display – all the workings fit miraculously

behind the screen. There is a DVD drive and photo software is provided, though this isn't as versatile as, say, Photoshop or Photo Impact, so you may wish to buy some additional photographic software if you decide you want to do a lot of photographic editing.

A desktop is the largest system, so much so that some don't sit on a desk as the name implies, but stand on the floor or in a desk cupboard. You will also need a screen, keyboard and mouse. These systems are usually the most powerful and flexible of all those available.

• A good-quality monitor. Cost is always a factor here. Most mid-priced laptops are fine and the iMac has a good screen. For a desktop computer an LCD screen, which is thin and light, with sharp, clear images, is most common, but a traditional CRT monitor will do just fine.

• A CD/DVD drive is really useful so that you can store photos on disk or make your own slideshows (see pages 22–23). Most modern computers have these built in, but you can always buy a separate CD drive that attaches with a USB or FireWire cable if you need to.

## Software

Digital cameras are usually sold with an assortment of software in a CD-ROM, but there are other programs that you can buy in addition (see panel, right). All software comes with its own user-friendly instructions, so you don't have to be a computer expert to use it. Just give yourself a few hours to sit down and become familiar with the program.

## Software choices

There are plenty of photo-editing programs on the market. As an artist, you won't need anything fancy, but you may be interested in making what improvements you can. Here are some of the programs you might consider buying:

**Adobe Photoshop** is probably the most well-known picture-editing software. There are several versions available, ranging from Elements, which contains the basics, to Pro, which can do just about anything. Elements, the cheapest package, is fine for our purposes. This is professional software, so the results are good but you'll find there is a lot to learn. Photoshop is available in both Windows and Mac versions.

**Nova Photo Explosion** is a very easy-to-use but effective program ideal for someone who only wants to do the basics. Like Photoshop, there are several versions available, from the standard version to Delux, but even the Delux version is significantly cheaper than Photoshop. Although the software is available in Windows or Mac versions, the Mac version can be more difficult to track down and is more expensive.

**Ulead Photo Impact** falls between Photoshop and Photo Explosion in price and ease of use. It is relatively simple, with plenty of automated programs to, for example, remove red eye, straighten horizons and improve focus, but it is also capable of some quite complex procedures. Most users feel that it compares favourably with Photoshop. At present it is available for Windows only.

**Corel Paint Shop Pro** is another good mid-priced program, and some users feel that it is as good as if not better than Photoshop Elements. It has a number of automated programs to, for example, correct perspective, replace colours selectively, blur backgrounds and quickly remove unwanted elements. It is for Windows only.

## From camera to computer

To transfer images from a digital camera to a computer you have two options: you can either use a card reader or you can connect the camera directly to the computer using a cable.

Some computers now have card readers built in, but if yours doesn't you can buy one that attaches to a USB (Universal Serial Bus) or FireWire port. There are many styles available. Look out for one that accepts several different types of memory card in case you ever change your camera or wish to download a friend's pictures.

If you are connecting the camera directly to the computer, the most common form of connection is a USB connection. All digital cameras have a USB port for connection to a PC and all come with a USB lead. Many cameras also come with a video lead allowing you to connect your camera directly to the television to show pictures on the screen.

Other options include FireWire, a fast data cable connection generally used with DSLRs, or wireless connections, which transmit data in a waveform without any cables. Wireless connections mean that you can work away from your computer to distances of up to 100m (350ft), depending on the type of connection and the wireless reception.

## Inky business

The quality of your prints depends not just on your choice of printer, but also on the inks it contains. Cheap replacement inks often don't provide colours that are as true to the original image as the more expensive inks and they can be frighteningly fugitive too. Surprisingly, an economical option is to have two printers, one containing cheap inks that you use for everyday purposes, and another with your expensive inks that you use for photographs and important documents only.

## Printers

Some digital cameras are sold with their own mini-printers, but most require you to have access to a standard printer. Many people buy a printer at the same time as their computer, but this isn't imperative and if you don't have a printer, there are many places that will print your photos for you. Most printers are inkjet, designed for general home and office use. The alternative is a laser printer, which is usually substantially more expensive. Printers come in various sizes, most often A4, but they're also available in A3 and A2 for larger prints – excellent but expensive. You can buy dye sublimation printers designed specifically for printing photos; they are brilliant for this, but can print nothing else. They come in a range of sizes, usually from 15 x 10cm (6 x 4in) to A4. See also the tip boxes above and opposite.

You'll need some paper to print on, of course, and your decision here comes down to budget, quality and personal taste. You can print pictures on ordinary copy paper, but there is no doubt that you'll get much better results on photographic papers. These come in matt, satin or semi-gloss, gloss and high-gloss surfaces, as well as fine art papers with watercolour-type finishes. Thicknesses range from about 90gsm (thin) to 270gsm (thick) or even more. Note that some printers struggle to feed through the thicker papers, so do check with your printer manual before you buy these. For our purposes here, any thickness is suitable, though the thinnest papers will need to be mounted in an album or sketchbook.

Choose your printer according to your needs. If you only want to print pictures, buy a photo printer; otherwise, an ordinary inkjet printer is the most versatile option.

## Scanners

Scanning prints, negatives or slides into your computer means you can print even damaged or faded photos. Most scanners come with the software needed to link to your PC. With flatbed scanners, you place photos on the flat glass 'bed' and you can scan to quite a high resolution. From these scans you can save photos on your PC or print them. Film scanners use much higher resolutions than flatbed scanners, but they are expensive, and unless you are prepared to pay a much higher price, scan only 35mm film. They are generally needed only for producing top-quality prints. 'All-in-ones' are combined scanners, printers and photocopiers. Often the scanner is of lower resolution than other types, but they are relatively inexpensive and versatile. You can also often get prints scanned for you at a photo lab.

## Camera film

If you are using a film camera, you will need to buy the appropriate film for your needs. All film, whether colour-print, colour-slide or black and white, is available in a variety of speeds, which are designated by an ISO number. ISO stands for International Standards Organization, which is the internationally recognized system for measuring film speed. The higher the ISO, the faster the film will react to the light, needing less exposure time. Bright light requires a lower ISO and dim light a higher one. As a general rule, very bright light needs about 100–200 ISO, while overcast or indoor light requires about 400 ISO.

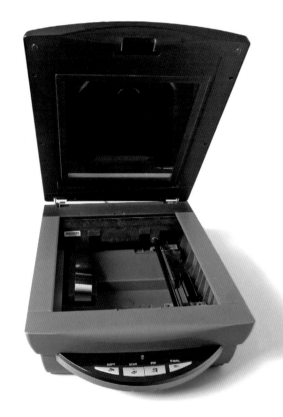

A scanner is useful if you have prints from film cameras that you want to transfer to your computer to work on and print out. Most photographic labs will also scan photos for you and put them on a disk.

Film remains the favourite of some photographers, but it is becoming increasingly expensive to have film developed as more and more people switch to digital.

### Printing without a computer

If you'd like a digital camera but aren't interested in using a computer or manipulating your photos to any great degree, consider getting a photo printer, such as Epson PictureMate. These are usually incredibly easy to use. Simply connect the lead from the camera to the printer (but beware, these aren't always provided with the printer) or insert your camera's memory card directly into it, then follow the instructions to print the pictures you require. Although you can't usually edit the pictures very much, you can print selected images or multiple copies. Many of these printers are small and can be run on batteries, making them highly portable.

# Using your digital camera

Although technological changes have revolutionized cameras on the inside, to the user things haven't changed all that much except that, if anything, cameras have become easier to use.

With a digital camera you don't have to wind on as you did with film, and in fact it is pretty much impossible to get a double exposure, even if you want to. All the auto functions on the new models mean that you don't even have to make decisions about speed or aperture – you just select the picture of the mountain for a landscape or the face for a portrait and away you go. And all that fiddling about trying to get the subject in focus is a thing of the past, because the camera does that too.

 **tip** Off-centre focusing

Basic cameras focus on what is in the centre of the scene. If you want, say, a house to be the focus, but you want it positioned to one side, focus first on the house by placing it in the centre of the shot. Partially press the shutter button to focus and then move the camera to position the house where you want it without releasing your finger from the shutter button. Now press down to take the picture, making sure you don't accidentally release the focus first.

## Using the controls

You can take a picture using just two controls on the camera: the shutter button and the 'mode' dial. Different modes indicated on the mode dial or on-screen menus automatically set up the camera for specific situations such as portrait, landscape or night scenes, and there are also settings that allow you to take control of speed or aperture, if you so desire. Other buttons include menus, flash and self-timer activator. The menus give a series of options for setting up the camera, for example, changing the date or resolution, adjusting the brightness or activating the zoom. If in doubt, ask your supplier to set the date and time as well as a suitable image size (resolution) for your purposes so that you are ready to go. Once you get more familiar with your camera, you can go into the menus and start experimenting.

## Focusing

Most digital cameras have an automatic focus, but your camera is just a mini computer – it can't make judgments – so you do have to ensure that it is focusing on the right thing. Usually, when you partially press and hold the shutter button, a green light or icon appears while the camera is focusing.

• If you are in poor light, concentrate on a prominent element through the viewfinder and turn to the camera's landscape setting, which uses a small aperture to get as much as possible in focus.

• With a group photo, to stop the auto focus from concentrating on a wall or middle distance behind and so blurring the faces, focus on one person's face or keep everyone's heads close together.

• When trying to get very close to a subject, you'll find that some digital cameras in macro mode can focus down to 1cm ($\frac{1}{2}$in). To enhance this feature, try using a tripod and select a small aperture if you are using manual settings. These manual settings can also be used when you're in poor light.

• Most SLRs and DSLRs have not only a centre focusing point but several off-centre points too, so that you can focus on a subject that is not in the centre of the frame without having to reset the camera position (see tip, above).

## Exposure

Exposure refers to the amount of light that reaches your camera's sensor and is the key to clear photos. Exposure is controlled by the camera's shutter speed, the lens aperture and the camera's sensitivity. The shutter is a small metal curtain that moves across the sensor. A fast shutter speed lets less light through; a slow shutter speed allows more light through. The faster the shutter speed, the faster the movement it will freeze. In overcast or gloomy lighting you will need a slow speed to allow sufficient light to reach the sensor or film, while to catch a moving object without blur, choose a fast speed.

The lens aperture is a small, adjustable circular opening in a diaphragm within the lens through which light passes to reach the sensor or film. The aperture size can be varied, with each position called an f-stop, typically ranging from f/2.8 to f/22 on a good-quality lens. The lower the f-stop number, the larger the aperture and the more light is admitted. The more you close down the aperture by choosing a high number, the more elements of a scene in front of and behind the subject will be in focus; choose a high aperture number, such as f/22, for a landscape to ensure everything is sharp. Conversely, if you open the aperture by setting a lower number, the range of focus will be smaller; choose a low aperture number, such as f/4, for a portrait if you'd like to blur the background. Modes on your camera such as the portrait or landscape mode will do this for you.

## Other considerations

As with film, the ISO setting of a digital camera controls its sensitivity to light. If you're taking a photo of a still object, use a low ISO setting, which allows for a longer shutter speed and produces a cleaner image. If you're shooting a moving object, then a higher ISO setting will be better. A higher ISO setting gives a faster shutter speed and requires less light.

Another important consideration, which might seem like basic common sense but that is often forgotten in the moment of shooting, is to hold the camera level. Most digital cameras have an LCD, which you can use to see your shots before taking them. Always look for any horizontal lines that you can use as guides, such as the horizon of a landscape or the back of a chair when taking a portrait. Also remember to stand still with feet firmly on the ground and legs slightly apart to provide a firm base. Hold your camera in place for a few seconds to make sure you get a sharp shot, and squeeze rather than press the trigger to prevent the camera from jolting.

### tip Spirit level

Keeping your camera straight can be more problematic than it sounds, especially if you happen to be standing on a slope or looking over something. You can buy mini spirit levels that fit onto the flash attachment on your camera to help with this issue, which you may find helpful.

*Straighten the horizon*

This shot required a small f-stop number to open up the aperture and get everything in focus. Notice that the horizon isn't straight. Don't worry too much, though, as this simple error can be easily corrected (see page 26).

### tip Speed and aperture

Shutter speed and aperture size work in balance to achieve correct exposure. In program mode, the camera will choose everything for you; in aperture-priority or shutter-priority mode you set either the f-stop or shutter speed respectively and the camera will set the other option according to the light conditions. For example, in a landscape shot you might want a small f-stop number to get everything as sharp as possible, and this will be balanced by the camera with a slow shutter speed. If this is too slow to handhold the camera, use a tripod or set a higher f-stop number.

# Processing your photos

One of the benefits of using a digital camera is that you can take dozens of pictures without having to pay for prints and you can simply erase any unwanted images. This means that there is no need to be frugal about how many pictures you shoot for reasons of economy.

You can take shot after shot of your subject until you think you have what you want, then delete any failed pictures straight from the camera. However, in the same way that you need to have enough rolls of film when using traditional cameras, you need to have enough memory space with a digital camera. Although some digital cameras have a built-in memory, most models store images on slot-in memory cards.

The next stage is to transfer the images somewhere else so that you can free up space on the camera to take yet more pictures. If you don't have a computer or you're away from home, take your memory card to a processing lab where the pictures can be transferred to a CD or DVD, sometimes in a matter of minutes. Otherwise, transfer them to your computer (see opposite). Digital images take up more memory than text files, so you need to be selective about which you save and also make back-ups wherever possible in case they are lost. Once you have either saved or printed your photos, you can erase them from your camera, regaining memory space.

## Memory cards

There are several different types of memory card that are not interchangeable, so you need to get the right card for your camera. You are likely to need an SD (Secure Digital) or XD card for a compact camera and a CF (CompactFlash) card for a DSLR, though there are plenty of exceptions. You don't need to buy a memory card of the same brand as the camera, but do make sure you buy from a reputable source as copies abound and these are not always reliable. Having said that, it is worth shopping around because prices can vary quite considerably and there are bargains to be had.

A selection of memory cards. The type of card your camera uses isn't as important as the amount of memory it has.

You won't get any choice about which type of memory card your camera uses, but you will be able to select different memory sizes. The more megabytes (MB) or gigabytes (GB) the card holds, the more pictures you can take and the larger they can be (see the box, below). Although you can start with a fairly small memory card and buy more cards later, it is usually cheaper to buy a large card rather than several smaller ones. As with computers, more memory than you need is better than less.

## Minimum card size

Memory cards are getting bigger, better and cheaper all the time. Here is the minimum card size you should buy, but if you like to take a lot of pictures you may want to buy a lot more.

- 2-megapixel camera: at least a 64MB card
- 3-megapixel camera: at least a 128MB card
- 4-megapixel camera: at least a 256MB card
- 5-megapixel camera and above: at least a 512MB or 1GB card

## Downloading to a computer

Most digital cameras are supplied with software that allows you to copy pictures to your computer. Once you've downloaded your images, you can view them on a larger screen and decide which are worth keeping. Your PC will ask you what you want to do with your photos, so you can choose whether to download them all or just some. Clear the check box next to any images you don't want. You can also rotate photos at this point, if necessary; to rotate a picture, click on it and then click either 'Rotate Clockwise'

or 'Rotate Counter-clockwise'. When you have reviewed your pictures for downloading, click 'Next'. Type a name for the group, click 'Browse' and select a folder to save them in.

To erase unsuccessful images from the memory card, select 'Delete Pictures From my Device After Copying Them', check the box and then click 'Next'. When you have finished, click 'Finish' and a new window will open to show you all the pictures you have just downloaded.

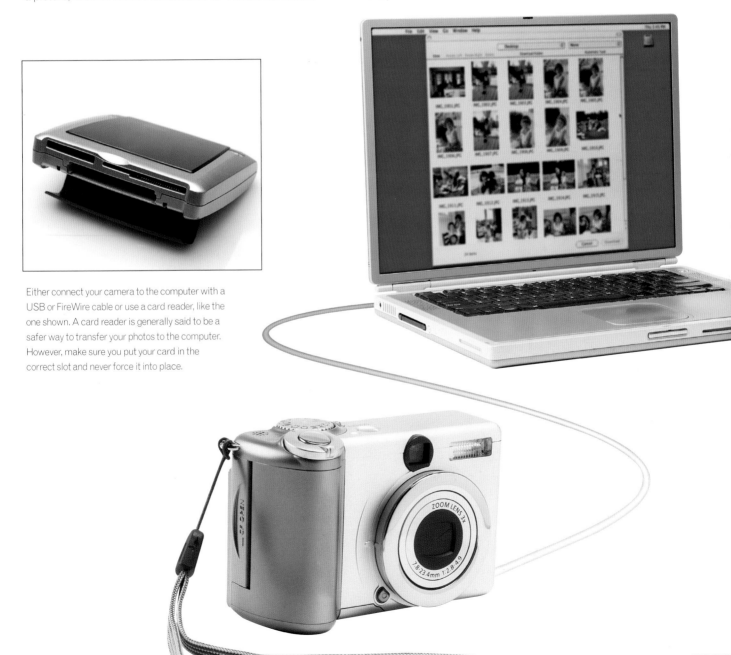

Either connect your camera to the computer with a USB or FireWire cable or use a card reader, like the one shown. A card reader is generally said to be a safer way to transfer your photos to the computer. However, make sure you put your card in the correct slot and never force it into place.

## Saving your photos

There are various ways of saving your work. If you click on File, the drop-down box will give you options of 'Save' or 'Save As'. The first time you press 'Save', a box will appear, asking where you want to save your image to and what you want to save it as. Each time after this, clicking on 'Save' will automatically override whatever you last saved, replacing it with the new version. 'Save As' creates a new version, so you can have the same picture but with different transformations on it. You will need to give the image a new name, but you can do this simply by adding a number or letter to the end of the original name.

When you save an image, you have to decide which format to use. There are several different file formats, each with advantages and disadvantages. Some will compress the file so that it takes up less space on your computer, and some formats allow you to choose how much compression you want. Compressing a file can reduce the amount of information the picture contains, but it does allow you to store more photographs. Your photo software may give you plenty of choice or it may be limited. Here are the most popular formats:

**TIFFs** (Tagged Image File Format) are lossless files, meaning that the data is compressed but no information is lost. It is the format of choice for important images and is the most universal and widely supported format.

**JPEGs** (Joint Photographic Experts Group) are lossy files, meaning that some information is lost, but they can compress files down to around 10 per cent of the original file size, which is useful if memory space is at a premium.

**GIFs** (Graphic Interchange Format) are lossless files but colours are limited, which they aren't with a TIFF. Although they are great for images with large expanses of even colour, they will lose any gradations of tone.

**PDFs** (Portable Document Format) are files of a type used by Adobe Acrobat. They are best for documents containing graphics and text, rather than images alone.

## Colour options

When saving or editing your photos on a computer, you may be asked which colour mode you wish to choose. Adobe Photoshop offers RGB, CMYK, Lab colour, grayscale, duotone, indexed colour and multichannel mode. However, unless you are a designer, book publisher or professional photographer, the only options that need interest you are RGB, grayscale and possibly duotone.

**RGB** stands for Red, Green, Blue. You can change the tones or intensities of the three colours used to create a staggering 16.7 million colours. RGB is used on the internet and by computer monitors, so if your photograph is in RGB, you should be able to get a realistic version of how the printed picture will look on your screen.

**Grayscale** has up to 256 shades of grey to give you a rich black-and-white image. You can also produce a black-and-white image by taking a colour image and reducing the colour saturation to its lowest level.

**Duotone** creates two-colour, three-colour (tritone) or four-colour (quadtone) images based on grayscale settings. This means that instead of just the black, white and grey midtones of grayscale you can add in extra colour.

### File formats

| File name | Compression | Colours |
|---|---|---|
| TIFF | lossless | RGB |
| JPEG | lossy | RGB |
| GIF | lossless | indexed colour |
| PDF | lossless | variable |

## Backing up

There are many ways you can lose information on a computer: error, accidents, lightning, or sometimes just equipment failure. If you make back-up copies of your files and keep them in a separate place, you can get some, if not all, of your information back if something happens to the originals. The most common method of backing up data is on blank CDs or DVDs, for which you will need a CD/DVD writer. If you buy rewritable disks, you can reuse them as often as you like. Alternatively, you can use a separate drive, such as a portable hard drive. As an added safety measure, disconnect these from the computer when not in use. Another convenient and very portable method is to use a memory stick or a photo storage device, or even an iPod. Some internet providers and printing sites operating over the internet will also store your photographs on their sites.

CDs and DVDs can degrade and suffer data loss, so always make two copies and replace them every five years or so, or ten years if they are described as archival.

## Organizing and collating

Printed images can be stored in folders, sketchbooks or scrapbooks (see page 30), grouped by subject or theme, but you also need to organize your digital files. Keeping a filing system that you can see instantly on your computer is a neat and convenient way of organizing your photos and it means you can access them at the click of a mouse. Move them around, arranging them into categories so they will be easier to find and use. You might want to store your pictures grouped by subject, such as flowers, landscape, beach scenes and so on, or keep all the pictures from a trip or event together. As you start this process, you will probably delete some rather than keep them all. Don't be too critical, though – even if some of your photos are poor, they might still act as workable ideas for paintings. Keeping everything clearly labelled on your computer in files or folders can be extremely helpful, whether you use the pictures now or in years to come.

CDs and DVDs are the cheapest and easiest storage devices. Label them with a CD marker or buy a CD labelling system that enables you to print labels to stick on the front. The more information you provide on the disk, the easier it will be to find what you want later. Really precious images should be stored in two places, either on two disks or on your computer or portable storage drive and a disk.

A photo storage device is designed specifically for storing your pictures. Some have screens so you can view your images or show them to your friends.

A portable hard drive can be used to store all sorts of files, not just your photographs. Remember to keep your pictures organized on it, stored by subject or event.

# Editing your images

Photos are your references, and the better your references, the easier your job will be when you come to make the painting. So, if your computer doesn't already have image-manipulation software, it is worth investing in some. There are many suitable packages on the market, each with similar editing functions and tools, and some have hint windows or 'wizards' that pop up to assist you as you need them.

You can take the editing stage as far as you like, brightening dark areas or toning down highlights, bringing out detail, removing distracting features, and so on. This is also a good time to assess certain compositional and colour questions, because once you get to grips with the software you can easily try different crops, add tints or even replace colours to turn a white dress into a red one, for example. You can even try experimenting with special effects, but if you want to keep things simple, try the following useful editing functions: cropping, straightening the horizon, resizing, brightening, darkening, improving the colours, sharpening and cloning. If you wish to use an old photograph, there are also some simple techniques for removing flecks and scratches.

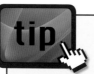

**tip**

**Save it**

Save your downloaded images in different folders to make it easier to find what you want later. Organize the folders by name: 'Greek Islands, Summer 2008', 'Fruits', 'Wild Flowers', etc. Keep various versions of the photographs you have worked on, perhaps with different crops or tonal values. These not only provide useful references later but also remind you of what you can do.

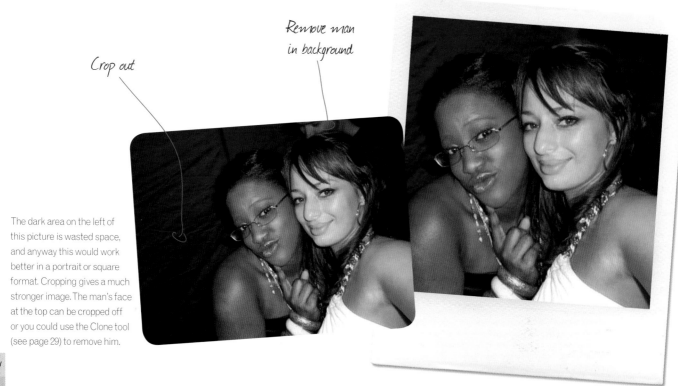

*Remove man in background*

*Crop out*

The dark area on the left of this picture is wasted space, and anyway this would work better in a portrait or square format. Cropping gives a much stronger image. The man's face at the top can be cropped off or you could use the Clone tool (see page 29) to remove him.

## Cropping

Cropping can be used to alter the emphasis of an image, to change the format – from landscape to portrait, for example – or to focus on a particular area of interest.

Open the photograph and click on the 'Crop' icon. Click the mouse button, hold it down and drag the cursor across the image, marking out the area you want to crop. Release the mouse. If you want to change the size of this cropped area, use your mouse to click on one of the arrows on the box delineating the cropped section. Hold the mouse down and drag either in or out, depending upon whether you want to make the area smaller or larger.

Once you are happy with your selection, delete the unwanted parts of the picture outside this box. If this newly cropped picture looks as you want, save it. If not, you can revert the picture to how it was formerly.

### Read the manual

Every software package works differently, even updated versions of the same software, so always read the manual or use the on-screen help assistant to familiarize yourself with the functions and capabilities of your software package.

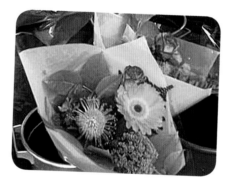

This image needs a focal point. Experiment with different crops to see what you like best. You might also decide to move the flowers to new positions when you come to paint them.

*Crop to this area and sharpen*

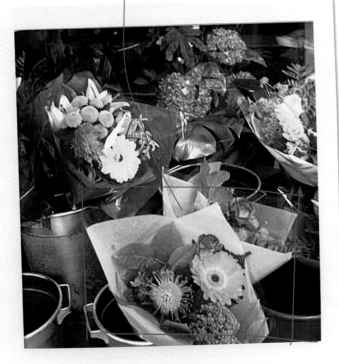

### Keep your originals

It is always useful to keep your original photos, especially if you have reduced the file size, cropped out information or changed the colours. Use the 'File - Save As' command, so that you save the amended picture without overwriting the original. You will need to give the image a new name. You can simply add a number, letter or word such as 'crop' or 'sepia' to the original file name, or take the opportunity to change the picture number to a more useful title such as 'Coronation rose crop'.

## Straightening

Sometimes, even when you feel certain that you kept the camera upright, your photos may come out slanted. For instance, the horizon might appear to slope or a building leans slightly – it's easily done if you don't use a tripod. You can either ignore the mistake on the photos and correct it in your painting or straighten the photograph on your computer.

If you are using Photoshop for example, open the image and activate the 'Grid' command (View – Show – Grid). A grid will overlay the photo. Using this grid as a guide, click on the 'Image – Rotate – Free Rotate Layer' command. Now click 'OK' and a new box will appear around the image with handles at the edges. Glide the mouse over a corner arrow until the little arrows indicate that you can move the picture. As with cropping, click and hold on a corner handle, but this time rotate the picture until it is straight. Then double-click inside the image and the adjustment will be complete. (With some software you may need to select the crop tool first.) Don't forget to save your work, renaming it in 'Save As' if you wish to keep the original.

*Horizon not level*

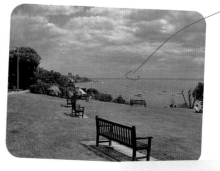

If the horizon isn't straight you may think that all you need to do is draw a straight line on your painting, but actually if the horizon is misaligned then everything else is out of position too – all the verticals and angles. The easiest thing to do is to straighten the photograph on your computer. You will then need to crop it to remove the blank areas from the corners.

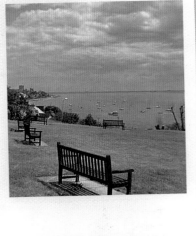

### tip

### High-quality printing

**If you want to make a high-quality inkjet print from one of your image files to display a photo you are especially proud of, set the resolution to 360ppi in the image size box.**

*Crop to this area and enlarge*

A chance sighting of wild horses looked disappointing in the photograph. Cropping in on the horses (see page 25) and then enlarging it helped. When cropping and enlarging like this, you may need to do some sharpening (see page 28) unless your photograph has quite a large file size in the first place. You could also try resampling to recapture some detail.

## Resizing or resampling

You may often want a large photo so that you can see more details as you paint, and occasionally you might want to reduce the size of a photo too. To do either of these things, you can resize or resample. Resizing changes the output size without altering the pixel or file size. In other words, the picture is larger but there is no more detail than before. Resampling actually changes the dimensions of the pixels as the image is resized, changing the file size too. It means that if you resample the image to make it bigger the computer cleverly fills in the details.

To enlarge using resize, open the picture and go to the 'Image Size' command in your software to bring up the image size dialogue box. Type the required dimensions into the height and width boxes. To keep the print quality high, don't let this drop below around 180ppi (often expressed as dpi). To resample, simply check the appropriate box before you save.

## Brightening

While modern cameras have extremely efficient exposure meters, you won't always get the exposure spot-on and you may sometimes find that the object you are most interested in, or even the whole picture, is too dark. Depending upon your software, you'll have a menu offering a control for highlights and shadows, plus a levels adjustment control. By brightening the image you can frequently bring back most of the detail that has become lost in darkness.

Open the image. Select 'Enhance – Adjust Lighting – Shadow/ Highlights' or equivalent from the drop-down menu. Drag any of the 'Lighten Shadows' or 'Mid-tone Contrast' sliders until you achieve your desired effect. Check any Preview boxes to make sure that the adjustments are as you want them. Once you are happy with the result, click OK and then save the image and its improvements.

## Darkening

A camera can't take in the same wide range of tones as the human eye and on occasion some areas of a photograph can look bleached out (often referred to as 'blown out'). By darkening the highlights, you can regain many of the missing details – though, with a digital camera, not as successfully as you can lighten shadows to find detail (the reverse holds good for film).

Open the image you want to adjust. In your image-editing package, choose 'Enhance – Adjust Lighting – Shadow/ Highlights' or equivalent from the menu. Drag the 'Darken Highlights' and, if you need to, also drag the 'Mid-tone Contrast' slider until you achieve the look you want. Check the Preview box to make sure that your alterations are as you want them, then click OK and save the image.

*Too dark – brighten image*

Here the camera has been unable to cope with extremes of tone. What was a wonderfully moody scene in real life has come out too dark in the photograph, and details on the boat are lost in shadow. By brightening the shadows many of the details have been restored so that they can be included in a painting if desired.

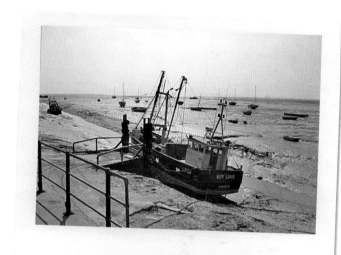

*Darken highlights to enhance sunset*

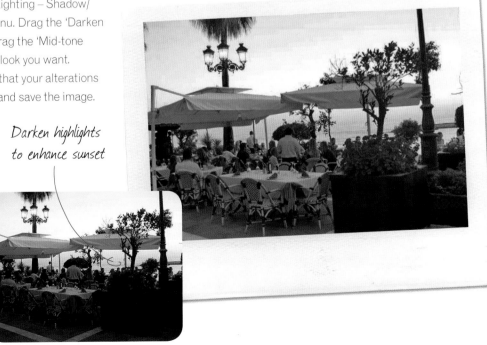

Here the sea, sky and sunset have been washed out, while the darker areas in the foreground are in shadow. Darkening the highlights and brightening the shadows will help and you might also wish to increase the colour saturation on the sea and sky (see page 28). If you can't get all the information you need in one version, you could always try two. You could work on one copy to improve the sea and sky and another copy to improve the foreground.

## Adjusting colours

All image-editing software provides for the control and adjustment of colour, and a few will even offer individual controls for each colour element. You may be able to do other things too, such as replace one colour with another or increase or reduce the colour saturation for a bolder or softer effect. Check your manual or help wizard for details.

Open the image and use your software's colour-adjusting tools to bring up the colour control dialogue boxes. Your software may offer 'Auto Levels' or 'Auto Colour', which can be a good starting point, or you may need to experiment with the Colour Balance adjustment tools until you achieve the desired result. Try the 'Adjust Hue/Saturation' tool. A drop-down menu will offer you various individual colour range settings or a main control that shows all the colours at once. Move the 'Hue', 'Saturation' and 'Lightness' sliders carefully to see the adjustments being made on your photo.

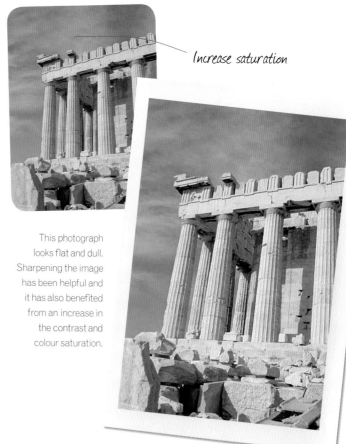

*Increase saturation*

This photograph looks flat and dull. Sharpening the image has been helpful and it has also benefited from an increase in the contrast and colour saturation.

*Out of focus – sharpen*

## Sharpening

Sometimes your camera focuses on the least important part of a scene and you find that your subject is out of focus. This is why it is always a good idea to take several pictures, zooming in and out if you can, so that between all your images you have what you need to make a good picture. However, you can sometimes bring more clarity to a picture by sharpening it.

Open the photograph and choose 'Filter – Sharpen – Unsharp Mask' and then adjust the sliders to sharpen the image as needed. If you want to work in a more defined way and have a suitable software package, you can select a specific area of the photograph with the Marquee tool and sharpen only that. This process can leave the photograph looking rather unnatural, but if it gives you the information you need to paint a good picture, that's what counts.

You can see in the original photograph here that the camera has focused on the leaves to the bottom of the chrysanthemum and the petals are completely blurred. Use your software to sharpen the chrysanthemum as far as possible. Increasing the contrast may also help.

## Cloning

Cloning is a wonderfully useful tool that effectively enables you to paint with pixels. Say you want to remove a distracting line of posts from a water scene (see right) or a waste bin from a street: you simply sample from a nearby area of the picture and paste that portion over the part you want to remove. Always sample from similar areas to make sure that the cloned effect looks natural. Depending on the condition of your photo, this could take you some time.

Open the picture and choose the Clone tool. It is usually helpful to enlarge the picture on your screen for accuracy and zoom in on the area you will be working on. Follow the instructions for your software to select an area of the picture close to the section you wish to remove – this may be Alt plus a click of the mouse. You may be able to select a 'brush' size appropriate for the job. Now paste the section you have sampled over the part you wish to remove. This may simply require placing the cursor over the section and pressing Shift click. Remember, if you make a mistake simply go to 'Edit – Undo'.

*Remove posts*

There is a distracting line of wooden poles in the water behind this musician. By using the Clone tool, all of them can be removed. Now that the area is clear, there might be space for a water bird or two. (Photo by Tony Nicholson)

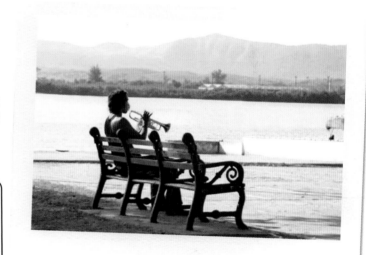

### tip — Using Layers

It can be hard to understand just how Layers work in photo-editing software, but it helps to imagine a collection of transparencies from a film camera with parts of an image on each. When they are all piled on top of each other you are able to see the whole picture.

*Clone out dirt*

## Restoring old prints

Scanning and editing techniques make it easy to restore damaged, scratched or dirty photographs.

Scan the original image in Photo Editor or another similar program. Open the image, create a duplicate layer with the 'Layer – Duplicate Layer' command and rename it whatever you like. Apply a dust-removal filter by using the 'Filter – Noise – Dust & Scratches' command, but take care with this as it can reduce sharpness. When you have removed any small defects, click OK. Create a new layer with the 'Layer – New Layer' command and rename the layer something that you'll remember. This layer sits on top of the first 'dust and scratches' layer and the original image layer. You can also use the Clone tool (see above). If you make any mistakes, click on Control – Z or Apple – Z or 'Edit – Undo'. Once you are happy with your tidying-up job, click on 'Layer – Flatten Image' and save your picture.

# A photographic sketchbook

Photographic references taken with a future painting in mind are different from those taken for their own sake; you are not looking for a single perfect image but a selection of shots that explore a subject in depth or act as an aide-memoire.

One way of collating photos so that you can refer to them in this way is to create a sketchbook. Putting printed photos into a book alongside sketches and scribbled notes is helpful for visual thinking; you can examine the images closely, which allows you to analyse individual elements, including shapes and tones. You may find that you want to include most of the information in a photo but exclude some unnecessary and distracting details, and you can try out in your sketches which aspects of the composition you want to emphasize.

Any sketchbook you create will be your personal and individual interpretation of what you find interesting, helping you to gain clearer insights into your own art. You may not use all of the ideas immediately – the beauty of a sketchbook is that you could be looking through it in a year's time or more and discover an exciting idea that you never carried out.

### Thinking in black and white
We all tend to think in terms of colour photographs, but there is a place for black-and-white prints in your sketchbook too. These act in the same way as pencil sketches in that they can help you see form and tone more clearly than in a colour picture. If you tend to copy colour photographs a little too closely, black and white prints can also help you loosen up and think more creatively about colour.

## TIP *Media interactions*

Some glues, paints and inks can affect a photo's colour or permanency, creating unsightly streaks or fades in a matter of days or even hours. Keep these items away from the front surface of your photographs – watch out for what is on the opposite page – or use acid-free products as designed for scrapbooking where possible.

## Gathering and selecting material

Whether you're making a sketchbook or simply storing or printing photos, it's a good idea to take several shots from different angles and viewpoints. If you are making a sketchbook, try to group subjects or themes together in categories. Even if you have only one photo of a subject, include it in the sketchbook, as it could still become the basis of a great painting. Themes don't have to be houses, people, trees and so on – they could be more ambiguous, such as natural form, sky, colour, texture, atmosphere, line or groups. A sketchbook of this kind can become a valuable tool for recording and developing ideas as well as a visual diary of your photos.

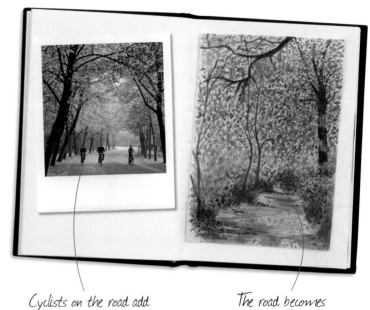

*Cyclists on the road add human interest*

*The road becomes an empty path*

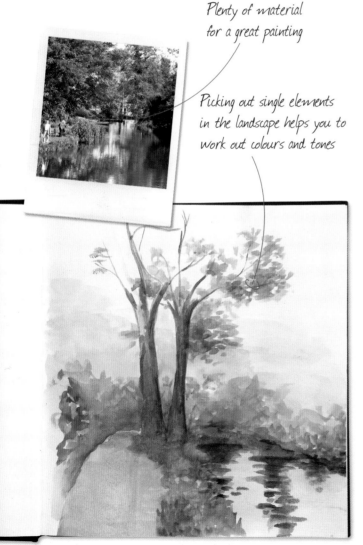

*Plenty of material for a great painting*

*Picking out single elements in the landscape helps you to work out colours and tones*

Experience will teach you which size of sketchbook suits your needs, but the choice is usually a compromise between having the space you'd like and the convenience of being able to keep the book in a pocket or bag.

## Buying a sketchbook

The type of sketchbook you should use for your photos really depends on what you intend to include in it (see Using a sketchbook on page 32). In most cases, an expensive sketchbook isn't necessary – a simple notebook will be sufficient. Just make sure that the pages are large enough for at least one or two photos plus some scribbled notes or small drawings – A5, A4 or A3 are all suitable, depending on whether you want to sketch on a large scale or have a sketchbook you can slip in your pocket. Having said that, do think about the other media you are likely to add and what they require in terms of paper texture and quality. If, for example, you do a lot of ink sketches, you'll want a paper that won't cause annoying bleeds, while if you like to use soft pastels for your sketches, consider paper with a bit of bite.

## Using your sketchbook

Your sketchbook is your personal space to record whatever you find helpful – photographs of the subject, sketches and possibly notes about colours, time of year or even feelings. Because of this, every artist's sketchbook will be different, but here are some suggestions of what yours might include and how you could lay it out:

• Place the photos with plenty of space around them so that you can see them clearly and possibly write comments or annotations beside them.

• Add small drawings of interesting areas from some photos to help you to focus on details that you may have missed earlier. If you don't know where to start sketching, begin by scribbling down a few marks that relate to your photo as quickly as possible. Ask yourself why you have chosen to snap that view: it might be the way the light falls on a subject, the shapes or the colours. Don't be afraid to challenge yourself and don't worry if you fail to produce the drawing you would like to – the whole point of sketchbooks is to develop images that you might not have considered at first or to help clarify what it is that appealed to you about an image or scene.

• Try using different drawing materials, including ballpoint pen, pencil, coloured pencils, charcoal or pastels.

• Use any tools at your disposal. Photocopiers and scanners are excellent for altering and experimenting with images. By enlarging segments of your photos you can sometimes reveal unusual abstract designs that weren't apparent to you in the original frame.

• If you feel self-conscious, don't take your sketchbook out, just use your camera. (Mind you, sometimes you might be so interested in rendering what you see on paper that you won't even notice onlookers.)

• Remember that these sketches aren't meant to be beautiful works of art. Even a diagrammatic thumbnail sketch will be useful if it shows you later what it was that attracted you to a view originally.

• If you think in words as well as pictures, add descriptive notes, poems or even single words that help to express the subject and your reaction to it. The more you analyse the subject, the more you will relate to it. Note down smells and sounds to help you recall the place in your mind when you come to paint it.

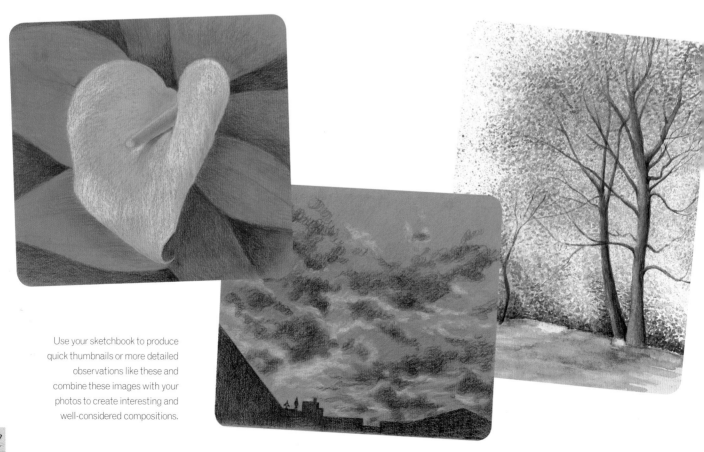

Use your sketchbook to produce quick thumbnails or more detailed observations like these and combine these images with your photos to create interesting and well-considered compositions.

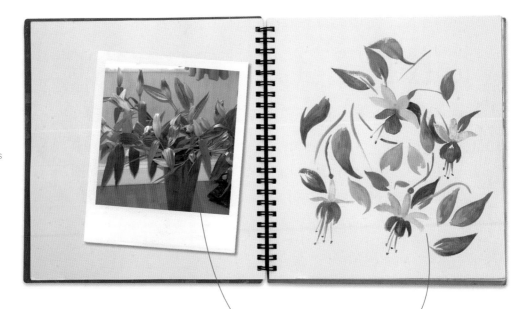

Colours, slight movement or overall shape can inspire ideas for final paintings or designs. Use your photos to try out different ideas.

Placing photos from the same sequence on the same page allows you to compare your sketches easily.

*Leave plenty of space around the photographs.*

*Colour and dynamism between flowers and leaves sometimes suggest patterns*

*Don't be afraid to simplify or alter what you see*

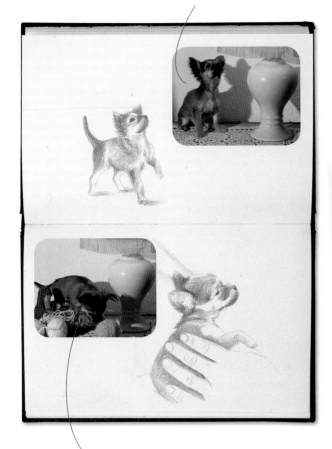

*This bright lily was an inspiring reference*

*Simplifying the background and petals creates a different sort of image that focuses on shape and colour*

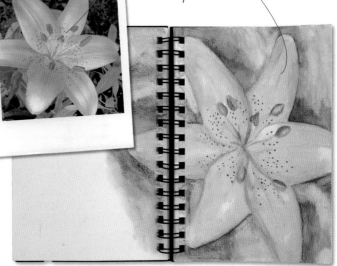

*Take several shots from different angles and viewpoints*

Use different media – whatever gets your point across. Combine detailed photos or sketches with more distant viewpoints.

# Making a reference library

Your photographic sketchbook will only hold so much information – your computer can hold masses more in terms of photographs and, if you have a flatbed scanner, sketches too. Consider your sketchbook to be a summary of all you have collected on your subject – you have plenty of space available in which to store back-up information that you can refer to whenever you need it.

One of the problems of digital cameras is that it is easy to become so overwhelmed by the number of images you have taken you find all your time consumed with sorting through them. Consequently, some discipline is called for! When you are going out to shoot subjects for painting, try to record only the things that you would otherwise draw or sketch. Resist the urge to shoot indiscriminately everything in sight just because it is so easy to point and shoot. However, when you find something you really like, it is better to photograph more than you need than to regret afterwards that you haven't shot enough. When taking your photographs, consider the following pointers:

• Keep your ultimate goal in mind at all times – these photos are references for a painting. Many of the skills involved in photography and painting are the same; success depends on good design and composition.

• Take some close-up shots to show details that you may want to include in your painting.

• The rectangular format of a photograph is not always the best shape; take pictures with more background than you think you might need so that you can experiment with cropping the subject in different ways later.

• Remember to turn the camera sideways sometimes so you have both landscape and portrait formats to play with.

• Think about each shot as if you were making a sketch. Does the picture add anything to what you already have? If not, be firm with yourself and don't take the shot.

## Using folders

Computers enable you to keep files within folders within folders. Say that you've visited a building that you'd like to paint and there are three possible viewpoints that you want to consider. You could create a folder for each, including any close-ups and distant views as well as the photo that you think you are most likely to use as your reference. Now store these three folders together in another folder named as the house name or location. This folder could then be stored in another folder that contains other buildings, for example. In fact, it doesn't really matter how you organize the folders as long as it seems logical and useful to you. Now when you're looking for inspiration for a painting of a building, all you need do is to click open a folder and sift through the photos.

## Good housekeeping

Treat your computer as you would any important area of your home or office. If your pictures are tidily arranged in folders within folders it will make your life much easier when it comes to finding what you want. Likewise, just as you throw away old magazines that you know you are never going to read, delete pictures on your computer that you know you won't want – or, if you are in any doubt, move them to disks or a portable hard drive. This makes space for new images and ideas.

Different angles and lighting offer fresh ideas for paintings. Silhouettes can make good backgrounds and contrasting tones can create unifying shapes, linking parts of an image together.

**tip** *Recurrent themes*

*Once you have taken several shots of various subjects, you will probably begin to notice that they all have something in common. For instance, you might be drawn to strong contrasts of tone, particular subjects such as flowers or faces full of character, or maybe simply brilliant colours or patterns. Once you realize what you tend to be drawn to, work on that. You may wish to take several photos of your subject, all slightly different, so you can draw out the elements that charmed you initially.*

Take several shots from different angles and viewpoints to help you get a full understanding of the subject and to give you as many options for paintings as possible, such as low viewpoints, putting the focal point to one side or standing in a position to create a strong sense of perspective.

# Drawing and painting techniques

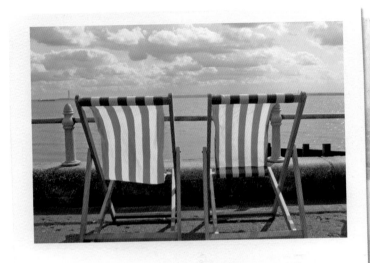

The choice of media for both drawing and painting is a personal one. You may already have a preferred medium for painting that you feel most at home with, but you should never be afraid of trying out something new as you may gain a lot of pleasure and achieve some results that surprise you. Some photographs seem to lend themselves to a particular medium, such as delicate watercolour, soft-focus pastel, colourful acrylic or impasto oil, so it's well worth taking a wider view of how you will treat your subject.

Whether you are an experienced artist or just starting out, this section of the book provides advice on materials and techniques that will help you turn your photographs into successful paintings.

Achieve sparkling effects of sunlight on water and solid objects using a dry-brush technique.

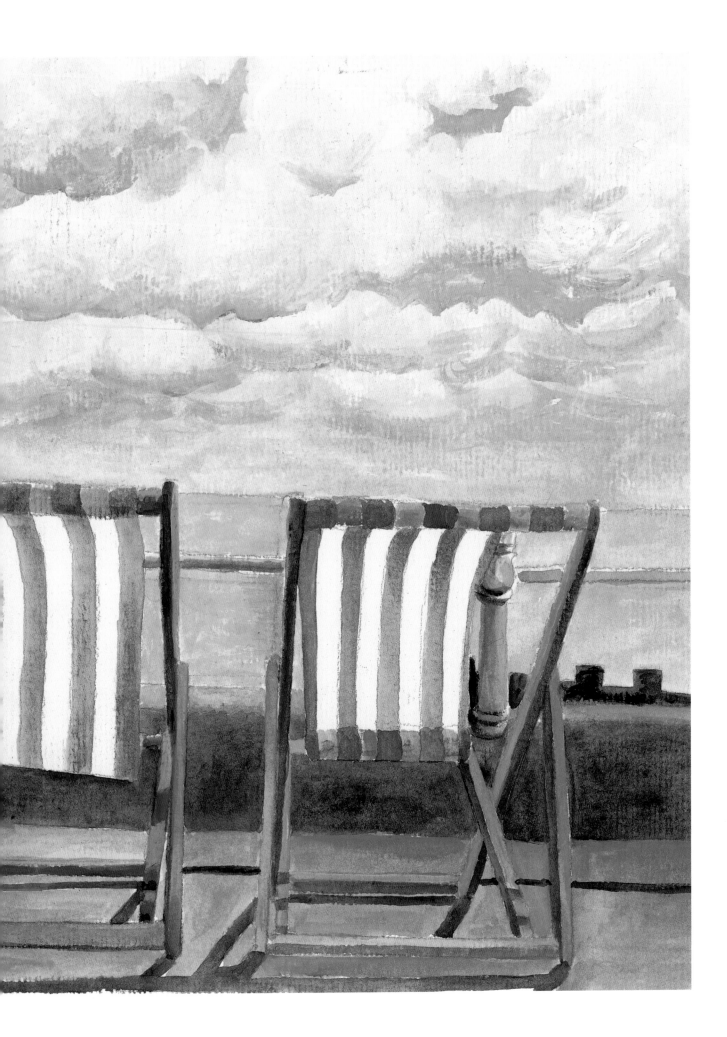

# Drawing media

**Pencils** are classified into H and B categories depending on the hardness or softness (blackness) of the graphite and clay core. Hard pencils range from the hardest, 9H, to H, while soft pencils range from the softest, 9B, to B. HB is midway between hard and soft and F, standing for fine, is similar to this. Soft pencils allow you to make broad, soft lines and tonal gradations, while harder pencils are good for fine lines and precise details.

**Charcoal** has been used as a drawing material for thousands of years. Today the choice is usually between willow charcoal, which is very soft and deep black, and vine charcoal, which tends more towards grey. Charcoal is easily blended, smudged and lifted, making it excellent for capturing line and tone quickly.

**Coloured pencils** can be blended, layered, burnished or used over watercolours or under pastels. They are versatile and can produce many unique and interesting effects. Adjusting pencil pressure affects the tonal values. Keep your pencils sharp and handle them carefully. Depending on how much wax they contain, some coloured pencils are softer than others. The 'lead' core is made of clay, coloured with pigment and bound with wax; the higher the wax content, the harder the pencil.

**Water-soluble coloured pencils** have the characteristics of ordinary coloured pencils but with the exciting modification that once applied, they can then be diluted with clean water from a soft brush to turn the colour into paint, blending the pencil marks. You can even use a wet brush to lift off colour to use elsewhere in your work.

**TIP** *Erasing to create highlights*

With drawing media you can create highlights by lifting out colour with an eraser – or, in the case of pastel or charcoal, you can even use a lump of bread.

Manufacturers produce coloured pencils in a very wide range of hues – up to 120 may be available in a single range. You can buy them individually or in boxed sets of various sizes. These look very tempting, but buying them separately means you can choose just the ones that suit your typical palette and avoid paying for pencils that you might never use at all.

# Pastels

Pastels come in a confusing assortment of textures and types, from oil and chalk to wax and water-soluble. The pigments are the same as those used to produce all coloured art media, including oil paints. All pastels are made with powder pigment and a binder. The composition and characteristics of an individual pastel stick depend on the type and amount of binder used; the higher the binder content, the harder the pastel.

**Chalk pastels** are available in varying degrees of hardness, with softer varieties wrapped in paper. They combine well with soft pastels, watercolour and gouache.

**Soft pastels** are the most popular pastels, having a high portion of pigment and little binder, which results in bright colours. These can be readily blended and so they require fixative to prevent smudging. Fixative can be applied after the drawing is finished or used additionally as required to fix the drawing in stages. Pastels should be used on pastel paper or card, which has a textured, sandpaper finish that helps to hold the pigment in place.

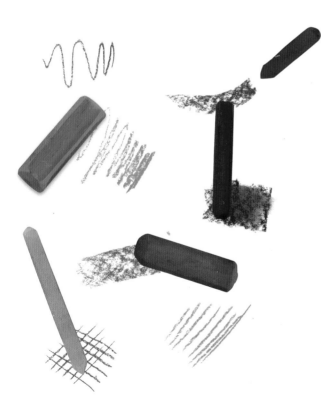

**Hard pastels** have a higher proportion of binder to pigment than soft pastels, producing a sharper drawing material that is useful for fine details. These can be used alone or added to pastel drawings to supply outlines and accents. You can use hard pastels on more or less any paper.

**Pastel pencils** are pencils with a pastel 'lead' and are useful for adding fine details. Use them on their own or combine them with soft pastels.

**Oil pastels** have a soft, buttery consistency and intense colours. They are slightly more difficult to blend than soft pastels, but do not need fixative. They are great for creating depth of texture because they can be applied really thickly or blended and smeared for smoother results. Once applied, they can also be diluted with turpentine or an alternative oil-paint thinner and then smudged and blended with a brush or cloth, creating thin glazes. Use oil pastels alone or combine them with oil paints and mixed-media work.

**Water-soluble pastels** are similar to soft pastels, but contain a water-soluble component, such as glycol, which allows the colours to be blended with water.

# Concept

Before you begin any painting you need to plan it, whether this is a detailed plan on paper or a simple idea in your head. However, you will already be considering how your painting will look when you are viewing your photos.

## Quick plan

A quick way to work out a concept for a picture is to apply light washes to represent areas of tone or colour and then pick out features with coloured pencil, charcoal, pen or paint.

Sometimes you will have ideas for different interpretations of a photo. Always remember that you can alter the reality of the scene, improving your composition by leaving out objects that are ugly or just badly placed for your purposes and emphasizing other elements, so keep an open mind and beware of simply copying what is there.

Once you are beginning to formulate a painting in your head, you need to plan where you will place objects on your paper or canvas. One of the most traditional ways of doing this is the squaring-up method.

If you look very closely, under the paint you will see the pencil grid that I used to place each flower in a composed and balanced position.

The watercolour painting shown left was planned by studying the photo above and deciding where to place everything. It's not a direct copy, but refers to the photo for ideas about shape and balance. Then I used the photo and painting to plan the close-up version shown right.

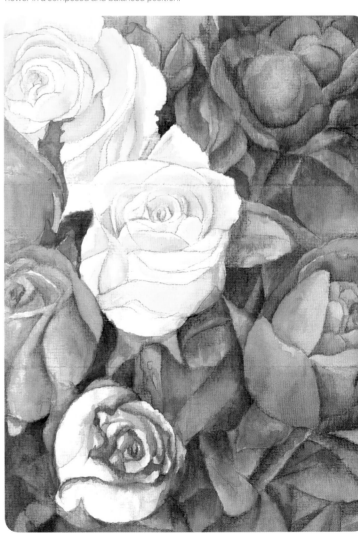

## How to square up

The squaring-up method allows you to enlarge the scene in any photo to the size that you want to make your painting. It is done by drawing a grid over the photo and reproducing, on a fresh sheet of paper and on a larger scale, exactly what's contained in each square. It's a relatively easy way of working, as at any one time you're focusing on only one square rather than the entire picture. Using a ruler and pen, you can draw the grid directly onto the photo or, if you wish to avoid damaging it, you can tape a piece of acetate on top of the photo and draw on that instead.

Draw a similar grid on your paper, but making the squares larger and using a pencil: begin each grid by forming a cross in the middle and then work outwards, drawing horizontal and vertical lines. Once you have completed both grids, study each square on the photo and draw what you see within it in the corresponding square on your paper.

Once you have become familiar with the grid method, you can train your eye to transfer what you see in your photos by looking for negative shapes (the spaces around objects) without needing to draw a grid.

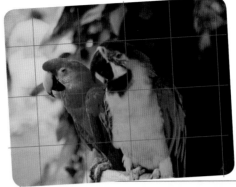

I used the squaring-up method to transfer the parrots in the photo onto my watercolour paper. (Photo by John Hodge)

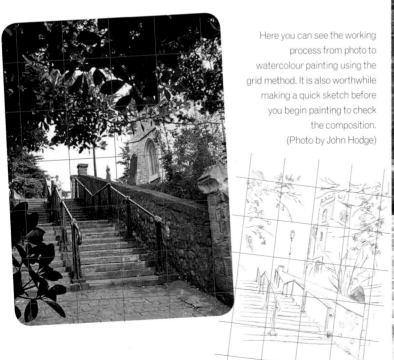

Here you can see the working process from photo to watercolour painting using the grid method. It is also worthwhile making a quick sketch before you begin painting to check the composition. (Photo by John Hodge)

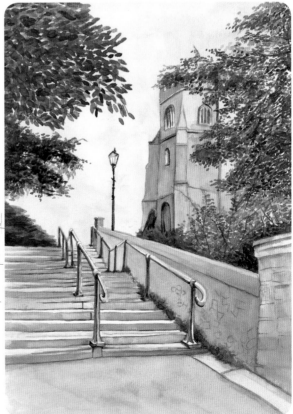

# Composition

**tip**

### Reducing detail

A good way of simplifying a photograph to make it easier to use as a painting reference is to make the depth of field shallower, thereby throwing much of the picture out of focus. You can do this by selecting a wide aperture on your lens, such as f/4. Now the subject will be in focus but less important areas behind and in front of it won't be, reducing the amount of confusing detail.

Your painting doesn't necessarily have to follow the same composition as your photos, but you are more likely to achieve a successful result if you think about composition at the earliest opportunity.

When you are taking a reference photograph outdoors, don't just stop at the first convenient position, but walk around to see if you can find a more interesting angle – paintings with unusual viewpoints always catch the eye. This is especially important if you are photographing a well-known location that has been painted and photographed many times before – the viewer's attention will be quickly lost if your picture looks like dozens of others. This isn't always easy to achieve, especially in a tourist honeypot that may be bustling with people. Making a very early start is one way of tackling this.

Early-morning photography also brings with it a potentially much more interesting quality of light than you will find later in the day. Early morning and late evening light are often particularly magical, or those moments when the sun breaks through cloud. You'll find more on this on pages 50–51.

Try to avoid including too much clutter in your photograph, because intricate details do not transfer well from photos to paintings (see the tip above). Of course, once you start to draw and paint you have the option to leave out any object or detail that appears in your photograph, but you will make things easier for yourself if you begin to edit your picture right from the start.

Another important early decision is the position of the horizon. Putting it in the centre has the effect of dividing the picture in half and creates a very static feel, so artists usually place it either in the top or bottom half of the picture space. Which you choose depends on whether you want to give more emphasis to the land (or sea) or sky.

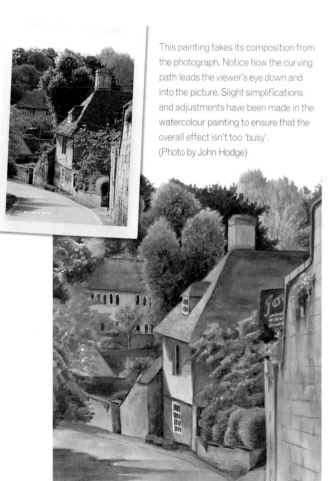

This painting takes its composition from the photograph. Notice how the curving path leads the viewer's eye down and into the picture. Slight simplifications and adjustments have been made in the watercolour painting to ensure that the overall effect isn't too 'busy'.
(Photo by John Hodge)

## Leading the eye

A well-composed picture leads the viewer's eye into and around the image. Paths, walls, rivers or, less obviously, shapes created by the positions of different elements or repeated colours or tones can all be used to do this. Make sure there is something to see at the end of your 'path' – a line that leads nowhere or, worse, takes the viewer's eye straight out of the picture is to be avoided. Try to have a focal point that you want the viewer to be drawn to, such as a boat on the sea or a particular feature in a landscape. The viewer's eye will always be attracted by a manifestation of human activity – even a small building in a broad sweep of landscape or a small figure dwarfed by a built environment.

Some of the most dramatic images are of quite mundane things seen from an unusual viewpoint. This box was full of plump ripe plums, and the photograph gave me scope for a great picture.
(Photo by John Hodge)

## Simplification

What you choose to leave out of a painting can be as important as what you keep in. There are no hard and fast rules and intricate details can make fascinating paintings, but pictures are often more powerful with fewer competing elements as too many details can make it difficult to distinguish what's important. With superfluous content minimized, the viewer is more likely to notice the main aspects of a painting. Details can also be reduced through the use of colour – brighter areas tend to attract the eye, so dull down areas you wish to draw attention away from.

## Viewpoint

Whether you look down, up or across at a subject makes a difference to the mood of a picture. For instance, a portrait photographed or painted from a low viewpoint (so looking up at the subject) creates a dominant image. Never be shy of trying bird's-eye views or any other unusual angle with your camera, but be aware that these dramatic viewpoints, especially if you are using a wide-angle lens, often mean some foreshortening and distortion that will challenge your drawing skills.

## Perspective

The term 'perspective' can refer either to your personal interpretation of an image or to methods of showing distance by means of aerial perspective and/or linear perspective.

Aerial perspective refers to the bluish haze you see as you look at a distant landscape, caused by particles in the atmosphere; details fade and colours are bleached to a blue-grey, becoming paler the further the landscape recedes. You can create a sense of space in your paintings by using aerial perspective, blurring distant objects and using pale, cool blues and greys. Conversely, give the objects in the foreground sharper edges, more detail, and stronger, warmer tones and colours.

Linear perspective describes the convergence of parallel lines at the horizon. The simplest form of this is one-point perspective where, for example, a railway track goes straight ahead into the distance – the lines draw closer together until they finally converge at the vanishing point on the horizon (your eye level). In two- and three-point perspective the lines are at an angle and the vanishing point might be out of the picture, but the same principle holds good.

The fairly high viewpoint dramatizes the perspective of this watercolour painting. The canal becomes almost arrow-shaped, encouraging us to follow it along and between the buildings. The contrasts of colour, tone and diagonal and vertical lines also attract the eye.
(Photo by Jean Ballabon)

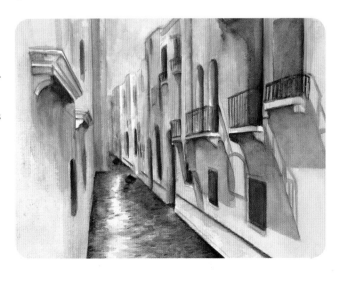

## Positions and shapes

When you are looking for a photograph or planning a painting, it is helpful to think of the overall composition in terms of basic geometric shapes. There is something very pleasing about such shapes, even if, when looking at a painting, we don't consciously realize that, for example, the faces of a family portrait make a circle, or a tall tree and house combine to form a triangle. Here are some useful divisions of the picture space to consider.

### Rule of thirds

Most of us have an instinctive understanding of placing points of interest a third of the way in from the sides or top and bottom of a picture to create a pleasing composition. This is known as the 'rule of thirds'. To put it into practice, imagine there are three equally spaced horizontal and three vertical lines dividing your picture and aim to put your focal points where they intersect. If nothing else, if you're not sure about the composition of a photograph, include three planes – foreground, middle ground and background. Although this composition may seem more appropriate for a landscape, it works well with other images such as portraits or still lifes too.

### The X-shape

The X-shaped composition creates unity because strong perspective lines from above and below the eye level intersect and lead the eye into the depths of the picture. The 'x' can be in the middle of the picture or to the side. Most of these compositions also incorporate horizontals and verticals to soften the 'x' shape. You can also emphasize contrast within parts of the 'x' – for instance, warm to cool, light to dark or hard to soft. The painting of the Venetian canal on page 45 is a good example of an X-shaped composition.

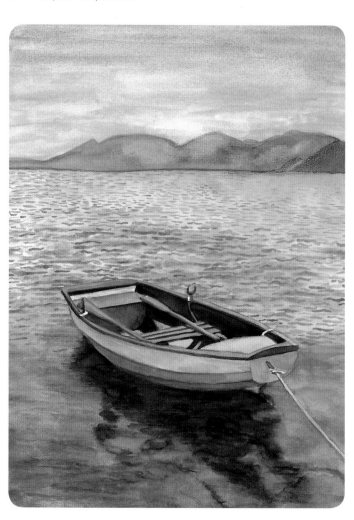

You don't have to make the division obvious when following the rule of thirds – just approximate three equal areas and you will find that your painting gains balance. Any large object in a scene has the tendency to unbalance it, but this boat is the only main object, so the calmness of the rest of the painting creates harmony. This was a subject ideally suited to watercolour. (Photo by Rupert Sutton)

**TIP**

*Space to move*

*Imagine a couple walking from left to right in a picture – the viewer automatically looks to see where they are going. If you position them on the right of your picture space, the viewer will either look right out of the picture or 'bump' up against the picture frame. Place the couple on the left of the picture walking in, and the viewer will look towards the centre of the picture, where you could strategically place another focal point. The same applies to any moving object – a bird, car, train or even an insect.*

This watercolour has quite a detailed composition, but repeated shapes and lines create harmony and balance. The seat in the foreground echoes the path through the archway, the horizontals of the bricks are repeated in the railings and parts of the bikes, and the verticals act as a coordinator across the composition, allowing us to judge the scale of objects within it. (Photo by John Hodge)

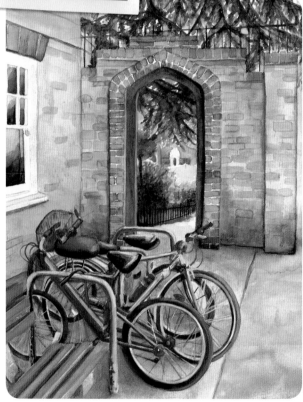

## Lines

Horizontal, vertical and angled lines all contribute to creating different moods in a picture. Straight horizontal lines give the impression of tranquillity, while an image filled with strong vertical lines tends to imply stateliness. Diagonal lines create dynamic effects, and a picture that has a diagonal element is generally livelier than dominantly horizontal or vertical pictures. While verticals and horizontals usually divide the space into areas, diagonals connect and lead the eye into the picture.

Using lines to link a main subject to a secondary one, or the foreground to the background, can help to suggest depth and substance, but be aware that you should put something at the top to stop the eye from running out of the frame. Too many lines without clear directions can create confusion and conflict, while curved lines or arcs are generally used to create a sense of flow. The eye usually scans these lines easily throughout the image. They can draw the viewer towards the main subject and create an energetic, harmonious and interesting composition. If you see an arc or curved line within a scene that you want to photograph, try to unite elements along or around it.

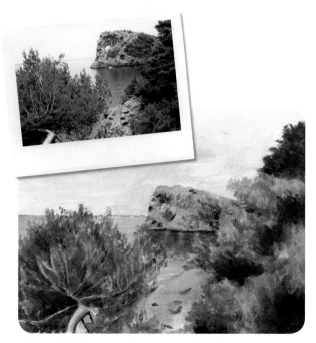

This acrylic painting has a diagonal composition, with a rugged path that leads the viewer's eye into and around the painting. The reflections in the water help to link the distant headland with the foreground, while echoes in the colour emphasize this. The lighter-coloured sky brings some air into a fairly detailed foreground.

## The triangle

One of the oldest compositional formulas of all, the triangle was used by Renaissance masters as well as ancient Egyptian artists to create balance and dynamism. The triangular shape can be made up of three subsidiary points of interest or one triangular form. Being a closed shape, a triangular composition won't lead the eye out of the frame. Be aware that if the elements of your picture make an equilateral triangle, the composition may feel static; an irregular triangle is more dynamic, but the eye can be led unpredictably around the image.

## Elements and shapes

Always try to use particular elements in a painting in odd numbers rather than even – for example, three or five trees rather than two or four. An odd number of subjects is more interesting as an even number produces symmetries in the image, which can appear contrived or static. The only time you might deliberately try to achieve a static effect is if, say, you are painting a monumental building and want to create a sense of stature and symmetry.

Consider repeating visual elements around the image, such as colours, shapes, textures or spatial relationships. This does not mean that you should make everything look the same, because visual contrasts and connections help to create powerful pictures. So, for example, group some items together, overlap others and vary the spaces between them. Either overlap objects decisively or leave a gap between them; if elements are just touching a weak shape will be created, which will distract the viewer's eye and cause a momentary pause.

Don't fall into the trap of getting stuck in a rut and using the same composition all the time, no matter how successful you may have found it to be. Vary where you put the horizon or focal points and swap between portrait (vertical) and landscape (horizontal) images.

**TIP**

*Change format*

*If you are always drawn to the same sort of subject and always use the same format – landscape, for example – your compositions could all end up looking rather alike. To get yourself out of a groove, make yourself try different formats. Try painting a landscape in a portrait format or vice versa, or experiment with square shapes, panoramics and so on.*

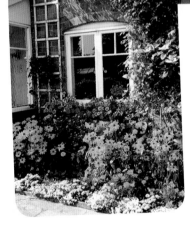

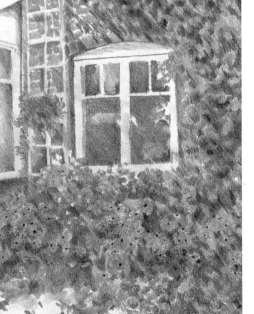

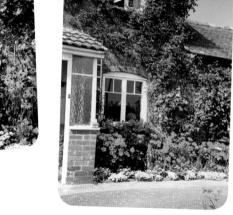

Several photos of this house and garden helped me to build up the idea of this well-stocked garden and redbrick house, along with an atmosphere of hot summer afternoons and the stillness in the air. For this I used coloured pencils.
(Photo by Dawn Taylor)

Here the subject has been placed in an S-shaped composition, painted in watercolour. The cottage gives a solid anchor to the painting, while the foliage and water soften it.

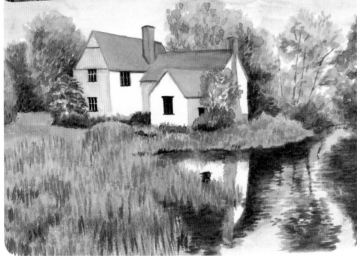

**TIP**

## Sketch it

If your scene is very complex, with moving figures, for example, and you are going to combine a number of photos, make a sketch to plot such transient elements as light and shadow or figures. Leave out anything that doesn't seem to help the composition.

## Combining images

You may sometimes feel that the composition of a painting could be improved if your photo reference included some additional features or had been taken from a slightly different angle. If you've kept a photographic sketchbook or reference file as discussed on pages 30–35, you may well have something to hand that you could use.

Combining photos can be extremely useful, but it's not always straightforward. For instance, if the light is different in each picture, you may have to invent shadows and highlights. Perspective might be different if you have taken the photos from different viewpoints, and figures might have moved or seem out of context. However, even if some of the photos are not quite in focus or colours vary, the amount of information you glean from these could help your compositions enormously.

Another reason why you might want to use multiple pictures as a reference for a single painting is if you decide to go for a panoramic format. Using a wide-angle lens might create distortions that you want to avoid, so the answer is to stand in one place and take a series of overlapping photos, moving the camera a little each time – it is important that the photos are overlapping because otherwise you will find it very difficult to piece them all together and you might end up with gaps.

Taking photos from several different viewpoints will give you wider scope for more exciting paintings.

# Capturing light

The benefits of noticing the quality of light cannot be overstated, as everything we photograph can reflect, diffuse and radiate light – in fact, the very word 'photography' means 'drawing with light'.

### tip Using a lens hood

If you are shooting towards the light, using a lens hood on your camera will reduce the amount of reflection off the lens, which will otherwise cause 'flare' in your photo.

Depending upon the time of day, the season, the weather conditions and local factors such as trees or tall buildings, photos – and of course subsequent paintings – can have many different moods. The trick is to understand just how the light is affecting your subject.

The time of day at which you take a photo has a profound effect on its appearance, as it is not only the strength of the light that changes throughout the day but also its colour. Around dawn and dusk, the sun is low in the sky and the light leans towards a soft blush. During the main part of the day, when the sun is high in the sky, colours tend to be bluer and shadows and highlights contrast more. Around noon, in bright sunlight, colours become intense and saturated.

If your subject is movable, try photographing it in direct or diffused light to create a different atmosphere or mood. If you can't move the subject, try moving around yourself to find the best lighting effects. Side lighting may produce shadowy surfaces, while backlighting tends to give extreme shadows and highlights (see below). Front lighting (that is, with the light behind you, hitting the front of your subject) produces the most even light of all.

Here the light is shining through the deckchairs and casting strong shadows on the ground. The dark tones in my oil painting were achieved with tertiary mixtures, but no black. (Photo by Dave Amis)

This was a view from above, with the light shining down on the plums. The light makes the colours bright and bold and the darkest tones deeper by comparison. With coloured pencils, this is emphasized with a variety of dark hues, including sepia and navy, but no black. (Photo by John Hodge)

With the help of the photo, I could see that the main light source was coming from the top right-hand corner and accordingly left white areas wherever the light was hitting the building and flowers. Although this is a fairly restricted watercolour palette, the light adds a lively dimension. When the light is that bright, the darkest tones will contrast dramatically.
(Photo by Dawn Taylor)

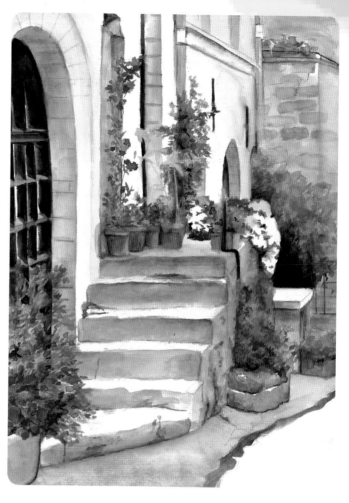

## Irregular light

There are times when the lighting is perfect for taking photos, and times when it isn't – but invariably there will be photo opportunities even on the dreariest of days or in the dullest of light conditions. Sometimes a shaft of sunlight will emerge through dark storm clouds, perhaps shining through leaves or between buildings, or sunshine will dapple on the sea or a river, sparkling on the water's surface. While beautiful light is important for the best photos, the weather is rarely so bad that it can't be snapped. Howling winds and lashing rain are ideal moments to capture storm-tossed silhouetted trees or subtle atmospherics.

Interior lighting affects colours. Inside this delicatessen, the lighting is warm and quite low key, although reflections and highlights are still noticeable. Along with the muted lighting, I liked the structured pattern of this interior. It is painted in acrylics.
(Photo by John Hodge)

## Working indoors

If you are taking photos in natural daylight, insufficient light for a successful exposure with a handheld camera is not usually an issue. However, if you're shooting indoors, the quality of artificial lighting will play a big part in the success of your shots. Inside, either use your flash (but be aware that this can have a flattening effect) or shoot near a window, which can add diffused light to a picture, creating a softening effect. If your camera lacks a flash exposure compensation function, the light it emits may be too harsh and could create heavy shadows in the resulting photo. A good idea is to leave any curtains or blinds open, allowing sunlight to stream in and flood across the subject, whether this is a still life, portrait or interior of a room. Alternatively, use a table or angle-poise lamp.

The most dramatic lighting for a still life is an artificial source placed to one side. This produces strong shadows and will emphasize the volume of the subject. Sometimes it produces shadows that are too solid, in which case place a piece of white paper or card on the opposite side of the objects. You will probably need to move it about until it reflects the light back into areas of deepest shadow.

## Low light

Dull light will shroud much of the detail in photos. Early-morning light, mists, drizzle, fog, rain, snow and sleet also produce indistinct shapes and forms. However, this isn't always an issue as you can create some lovely impressionistic work using your reference photos, working comfortably at home rather than shivering outdoors. Alternatively, you can gain more information about your subject by taking additional close-up photos and also use computer techniques to brighten the pictures, increase the contrast and sharpen the focus (see pages 27–28).

Sometimes low light actually enables you to see more detail. This is because very bright light can produce glare and dark shadows and you may not be able to successfully recover the detail from these areas on the computer. Many professional photographers avoid taking pictures in the middle of the day where possible for this reason.

# TIP *Painting contre-jour*

*'Contre-jour' means 'against the light'. Pictures looking into the light have a wonderful sparkling quality. Objects are thrown into silhouette, giving the entire image high tonal drama and contrast, hiding details and emphasizing lines and shapes. This lighting condition can be very difficult to capture in a photo because the sun can create a lot of glare and the camera can struggle to set the correct exposure to deal with the high contrast, but if you can do it successfully you have the basis for a wonderful painting.*

(Photo by David Guyver)

## Misty morning

Mood can be greatly enhanced by the way in which you paint the light. This atmospheric morning scene was painted in three simple stages and needed little adjustment from the original photo.

**1.** Create a wash in yellow ochre to cover the paper. When this is dry, begin to paint leaf shapes in Hooker's green and ultramarine using the tip of a round brush, flattened on the paper to create the shapes each time.

**2.** Continue building up layers of leaves, then add a light, grainy wash at the bottom of the paper using burnt umber and ultramarine. Put in the horizon line with sap green, a touch of cobalt blue and burnt umber. Paint the distance in ultramarine with a touch of burnt umber.

Darken the foreground and the distant trees. Using either the tip of a round brush or a rigger, paint in small details in the foreground.

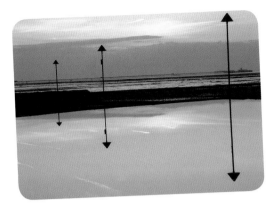

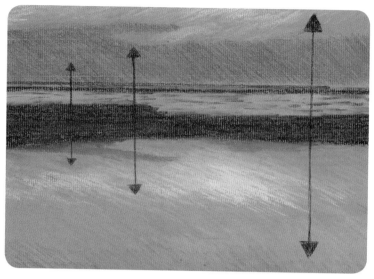

Early mornings can be very atmospheric and chalk pastels have a wonderful immediacy that allows you to capture the effects with minimal marks and detail. Using a range of tones from strong darks to white, atmosphere can be built up with quick, sketchy marks. It's best to let your mark-making show through with pastel paintings like this, as it gives an impression of spontaneity and immediacy.
(Photo by Dave Shields)

This is an example of direct but subdued light, which gives the painting a subtle, almost flat style. There is evidence of light, but it's muted and gentle. I also liked the connection of the dog's honey-coloured coat linking with the golden bricks.
(Photo by Dave Amis)

## Shadows

Although the shadows in your photograph may appear to be grey or deep black, rather than painting them as such you can make them much more interesting with your use of colour. Shadows actually contain colour from various sources. First there is local colour, which is the colour of the object that the shadow is on – a shadow on a red brick wall will still contain some of the colour of the wall, for instance, though it will be dulled down. Then there is the colour of the actual shadow. The Impressionists realized that shadows contained the complementary of the object's colour (see pages 56–59), so, for example, a yellow banana casts a purple-tinged shadow, which might also contain some reflected colour bouncing off nearby objects. If you take all this into account, the shadows in your paintings need never be a dull, flat grey. Even if you can't make out any colour in the shadows in your photographs, you can simply use your knowledge to guess what they might be.

Also consider the size, shape and tone of the shadows in your picture. At midday the sun is bright and overhead, so shadows are short and there is a strong contrast between lights and darks. When the sun is low in the sky, in the early morning or late afternoon, shadows are long and the contrast between shadows and highlights lessen.

# Tone

## After light, the next thing to consider in your painting is tone. Tone is the relative lightness or darkness of a colour, often referred to as 'value'.

Some of the most dramatic paintings can be created from extreme contrasts of tone or value, but close-toned photos also make interesting paintings, especially when contrasting colours are in close proximity to each other.

When you are taking photos, remember that few cameras can cope with extremes of light and dark and usually either the brightest lights will be 'blown out' or the strongest darks will be rendered as solid black. In both cases, you will have areas that contain no detail. To compensate for this, make quick sketches or write colour notes, so that you acquire as much reference

material as possible. Trying to remember the subtle nuances of tone when the image is not in front of you is not easy and detracts from the point of using photographic references in the first place, so focus your camera on any shadows and highlights, recording all the details you can of the subject, even if some of your photos turn out to be extremely dark. The more information you can gather, the better.

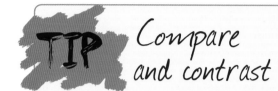

**TIP** Compare and contrast

It's not always easy to work out how dark the dark tones are or how light the highlights. Try holding a piece of white paper next to corresponding parts of your photo and painting as you work. Use the white as your 'measure' to compare lightness and darkness e.g., if an area is considerably darker than the white, make sure it's correspondingly dark in your painting.

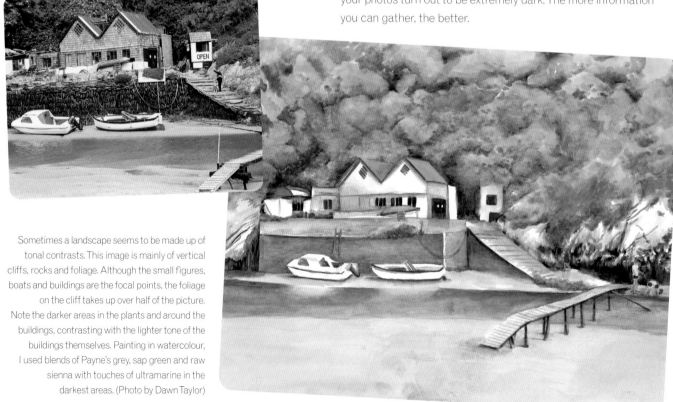

Sometimes a landscape seems to be made up of tonal contrasts. This image is mainly of vertical cliffs, rocks and foliage. Although the small figures, boats and buildings are the focal points, the foliage on the cliff takes up over half of the picture. Note the darker areas in the plants and around the buildings, contrasting with the lighter tone of the buildings themselves. Painting in watercolour, I used blends of Payne's grey, sap green and raw sienna with touches of ultramarine in the darkest areas. (Photo by Dawn Taylor)

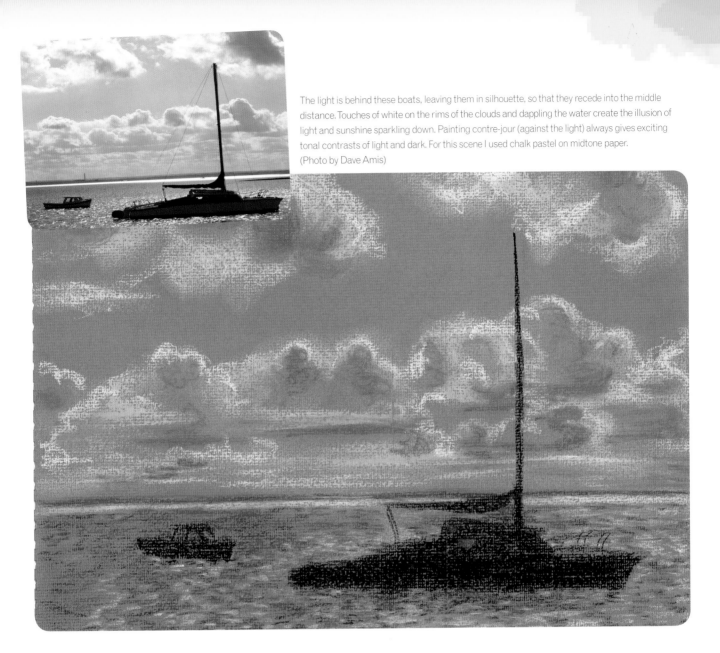

The light is behind these boats, leaving them in silhouette, so that they recede into the middle distance. Touches of white on the rims of the clouds and dappling the water create the illusion of light and sunshine sparkling down. Painting contre-jour (against the light) always gives exciting tonal contrasts of light and dark. For this scene I used chalk pastel on midtone paper. (Photo by Dave Amis)

## Working with three tones

When it comes to painting, if you're not confident with depicting the multitude of tones in everything you see, restrict them to just three: light, mid-tone and dark. This simplifies things, gives you a degree of control and provides some unity in the picture. Most paintings need only a small range of tones like this to create drama and focus.

It is almost impossible to determine a tone until you see it against another, so to establish the tonal value of objects you need to compare them with other tones surrounding them. By squinting with half-closed eyes you will reduce the level of detail you can see, whether in the actual subject, the photo or your subsequent painting, which emphasizes the light and dark areas. Mid-tones are harder to estimate, but they will be more

identifiable once you have recognized the strongest darks and the palest lights.

Colour and recession in a painting are enhanced by clear use of tone. Used judiciously, tonal contrast also creates patterns and highlights areas of interest, drawing the viewer's eye around the painting. If you feel that a painting isn't working, check the tonal range – it may be too narrow. An easy way to do this is to print your reference photo in black and white or to photocopy it, which helps you to establish the tonal range without the added element of colour to distract you. Beginners often fail to make the tonal contrast in a painting strong enough, but equally an experienced artist can misjudge a shadow or highlight and make it too severe.

# Colour

The mood of a picture is primarily dictated by the use of colour. Whether in your reference photo or your resulting painting, strong or dominant colours can give emphasis to an area, while soft, muted colours can add mystery or fluidity.

## Interpreting colour

• Photographs are often criticized for having flat and lifeless colours. Counteract this by using a range of harmonious or contrasting colours in flat-looking areas.

• Remember that atmospherics cause colours to change depending on how near or far they are from you. Foreground colours are the warmest and strongest and have the widest range of tones. With distance, colours lose their intensity, becoming bluer and lighter with less tonal variation. In order to create a sense of perspective, strengthen and intensify some foreground colours and dilute colours in the background.

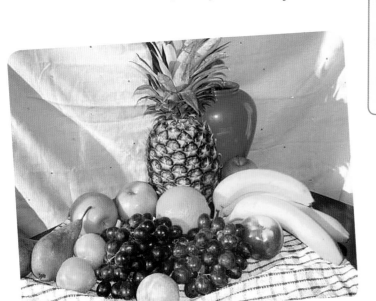

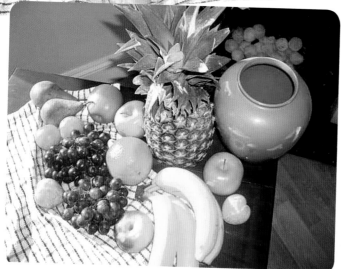

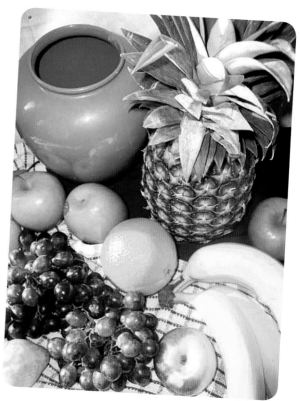

Taking photographs makes it easy to try out different compositions, lighting and colour arrangements, as shown here. Arrange the same set-up in front of a light and dark background. Try moving the light source and shoot from different angles. See how the placement of certain colours, such as the blue of the vase, affects the colour balance.

# Using colour

You can use your colour palette to influence the mood of your painting, to help create a sense of depth and to draw attention towards or away from certain features.

### Colour temperature

Colours are described as being warm or cool. Warm colours, like reds and oranges, appear to advance, so use them on areas that you want to bring forward, such as the foreground of a field. However, all colours have a cool and a warm version. For instance, red with a touch of orange (for example cadmium red) is warm, while red with a touch of blue (for example alizarin crimson) is cool. The cool colours, which include blues and greys, recede. Use them on areas towards the back of an object or composition to create depth. Cool colours can be made to look cooler still by putting warm colours beside them, and balancing colours in this way will give you dramatic compositions.

### Complementary colours

Colours that are opposites on the colour wheel, such as blue and orange, red and green, or violet and yellow, give punchy results when they are placed near to each other. Known as the law of simultaneous contrast, this was a favourite device of the Impressionists and can be used to intensify the impact of any picture. For example, even if a yellow flower appears to have a grey shadow, by including violet in the shadows you can give your painting extra dynamism.

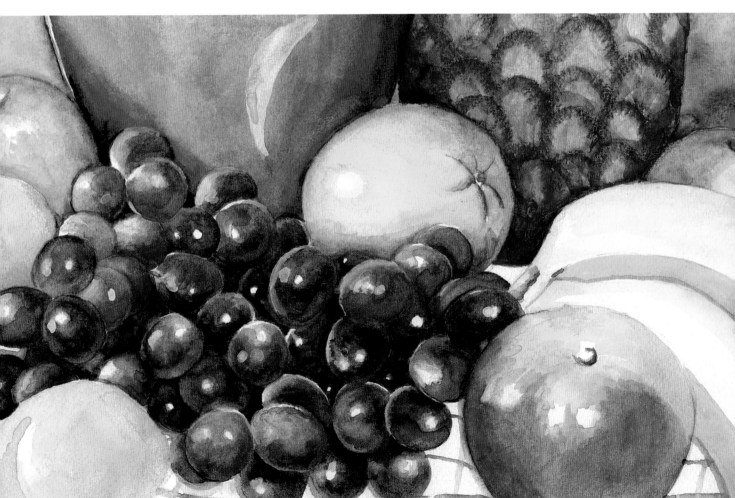

Painting fruit offers the opportunity for uninhibited use of colour. This watercolour painting shows a riot of warm and cool colours and contrasts of complementaries.

## Harmonious colours

Colours that are close to each other on the colour wheel, such as blue, turquoise and green, or red, orange and yellow contain nothing discordant to distract the eye, creating a sensation of calm. Nothing dominates, but if you want something to stand out you can add a flash of complementary colour for instant zing.

## Colour contrast

The apparent strength of a colour can be enhanced or minimized by those surrounding it, so you can boost the impact of a colour by placing it against a darker one or a complementary, or conversely lessen its dominance by putting it close to similar colours. If you are setting up a still life or portrait, try it against a light background and then a dark one to see which effects you prefer. The stronger the light illuminating your subject, the brighter the colours will appear. If it is possible when you are taking photographs, try to shoot the subject in hazy light as well as bright light to give yourself more options when you come to paint the scene.

## Spot colour

Adding a touch of colour that is not part of the main palette can be very effective for drawing attention to a focal point. At an exhibition held at the Royal Academy in 1832, J. M. W. Turner famously detracted attention from an adjacent landscape by Constable by placing a blob of red paint on his predominantly grey seascape.

### Judging colour

Photographs do not always record colour correctly and different film types will produce different results, with warmer or cooler reds, for example. Always use your own instincts when it comes to mixing colours.

In this photo a shallow depth of field has pushed the background out of focus. The light shines directly onto the poppy, highlighting veins and contrasts of darks and lights, while bleaching out any superfluous details.

I altered the proportions of the photo slightly to emphasize the large, floppy petals. I used a mix of warm colours – cadmium red, cadmium orange and scarlet lake – against cool greens made up of gamboge and lemon yellow with ultramarine and Prussian blue. The whiteness of the paper shows through the translucent watercolour to describe the highlights on the petals.

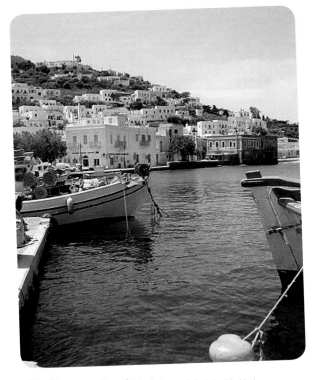

I liked the composition of this photograph, but decided to lose some of the buildings on the hillside and the confusing cluster of boats on the left in the middle distance. The Mediterranean sun makes colours hot and zingy, so I upped the colour saturation when I came to interpret the scene in watercolour.

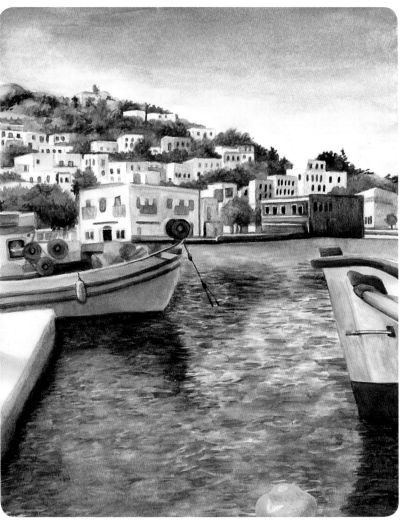

Transparent washes of gentle, harmonious blues were used in this watercolour, with a few sparkling white highlights on the water. The lemon spot colour draws the viewer's eye around the scene, and the buildings in the distance give focus to the expanse of calm sea.

The viewer's eye is irresistibly drawn to a speck (or two) of bright colour in an otherwise fairly neutral picture.

### Limited palette

This term refers to the use of a fairly restricted number of colours in a painting. Most artists tend to work with a limited palette because it helps to provide harmony and continuity and avoids the muddy combinations that can result from mixing too many colours. Turner often painted with a palette of only six colours, and several of the paintings in this book were produced using just the three primary colours – red, blue and yellow – plus white. However, when you are using dry media, such as coloured pencils and pastels, a limited palette should be avoided as colours are needed to build up depth.

## TIP Mixing dark colours

Small touches of black can be useful to add powerful accents, but colours are best darkened by adding their complementaries – mixing them with black can have the effect of deadening or dirtying them. The darkest colours can be created from mixtures of browns, greens, violets or blues, as even the merest hint of light gives darkness a trace of colour.

# Movement

Your first reaction to the idea of movement in a painting is probably to think of a figure, bird, animal or vehicle captured in motion. However, to an artist, movement can encompass much more.

Movement can be subtle – the wind ruffling leaves or flower petals, for example – and can also be suggested by a liveliness in painting technique that makes figures and animals look animated even if they are not actually in motion. In addition, you may hear it said that a painting has a lot of movement with the meaning that it possesses dynamism or energy (see Dynamic compositions, page 62).

## Photographing movement

When we watch a moving image on television or in the cinema we often see the entire action from start to finish, but when we take a photo or paint a picture we can only ever capture a split second of that movement. Although it does become easier with practice, it is difficult to do a drawing such as this straight from life. However, with the aid of a camera you can make things much easier for yourself. Building up a reference library of shots that you can refer to for future paintings is a good idea, so don't miss the chance to record movement even if you have no particular subject in mind.

A fast shutter speed (or the moving figure mode) on your camera will freeze the action instantly and you may find that everything is in focus, but sometimes you can convey more of a sense of movement if the subject or background is a little blurred. Depending on your camera, you may be able to take a shot that shows slight blurring by choosing a standard or slow shutter speed, such as 1/60. This is always a bit experimental, because the faster the subject is moving, the faster the shutter speed needs to be not to blur the movement. If you are photographing a car racing by, you should have quite a lot of blurring at 1/125, whereas a person walking might be in focus at that speed, especially if they are facing directly towards or away from you. Either the frozen moment or the blurred-effect photo can be used as the basis of dynamic and exciting paintings.

**tip** Photographing movement

If you are able to, take several pictures of the moving object using different shutter speeds on the camera. Use the Tv setting on the camera if you have a DSLR or, if you can't set the shutter speed manually, experiment by using different modes on the camera including the moving figure and portrait settings. This way you should be able to get some shots with everything sharp or only slightly blurred and some shots with more blur. Now you can use the best bits from each photograph to produce the ideal painting.

Although this is a stationary subject, I interpreted it in oils with fairly dynamic, almost dabbing brushmarks to give the impression of movement.

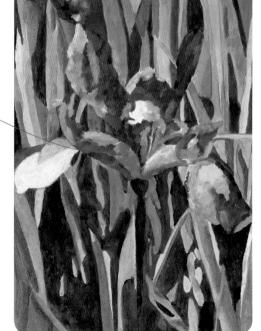

*For this effect, use a flat brush in quick dabbing marks for the flower and longer, slower strokes for the leaves and stems*

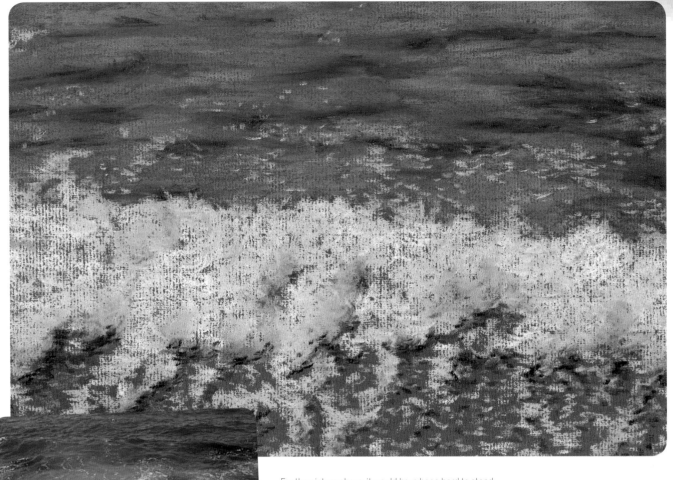

For the picture above, it would have been hard to stand
so close to the waves at the edge of the shore while
I captured them in chalk pastel. Using a photo meant
I could keep my paper dry and also study the shapes
and contrasts of the receding and advancing water.

A fast shutter speed will freeze nearly any
movement. However, if you want a blurry,
impressionistic look, as with the waves or golfer
in action, simply point and click or even slow your
shutter speed. With slow-moving images, such
as these donkeys, try painting them in a sketchy,
loose style to create more dynamism.

## Dynamic compositions

In order to portray vitality and energy, there are several techniques that you can employ when translating photographs into paintings. First of all, try to find and show rhythm in your pictures by repeating shapes and colours across the painting. This leads the viewer's eye around the painting in a fluent way. Diagonal lines also emphasize the drama of a moment and, by leading the viewer's eye directly across the painting, instantly give a sense of motion (see page 47); sinuous curves or flowing lines portray gentle movement, while zigzag or staccato lines express agitation and restlessness.

A moving subject can be conveyed not only through the relative positions of one shape against another, but also by showing the relationship between the subject and its surroundings. For instance, a blurred background or suggested shapes rather than details give an impression rather like being in a moving train, while slightly blurred subjects such as people, animals or vehicles gives the appearance that they are in motion.

## Less is more

Work quickly, applying just a few strokes to capture the essence of what you want to convey. When we see motion we don't have time to focus on details, so a painting of a moving image should omit them. By putting in only the essentials, you will transfer the energy of the action into your picture. If you are using pastels, smudge your work with a piece of tissue, kitchen towel or cotton wool when you've finished; if you're working with watercolour or gouache try spraying water from a spray mist bottle; in the case of oils or acrylics, smudge your paint in the direction of the movement as you work.

When you are painting storms or waves, 'feeling' the flow and rhythm as you work in the direction of the movement will help you to avoid stiff, motionless weather and water effects. Your paint should flow as fluidly and naturally as the shapes in the scene you have photographed, though including some broken lines can also give the idea of velocity and of the subject being too fast to capture.

**Observe and sketch**

When you are trying to instil movement into your paintings, try not to work entirely from a photo. Watch the subject moving around for a while and then keep that sense of movement in your head while you work. Let your hand move to the rhythm of your subject while you paint. Try making some quick sketches too – this will help you to get a feel for the action.

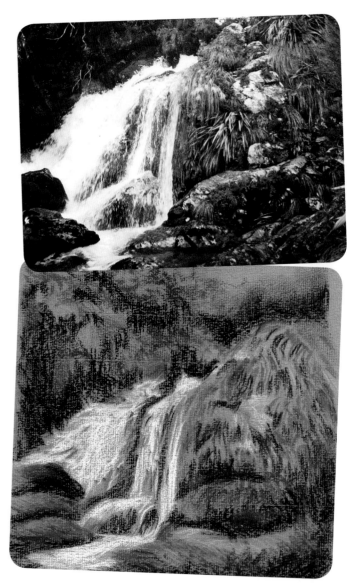

*Less really can be more! A tumultuous waterfall is captured here with speedy pastel marks. Watercolour washes would have worked well too, or even ripples of very diluted acrylics or gouache.*
*(Photo by Helen Greathead)*

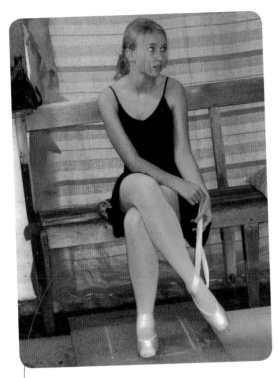

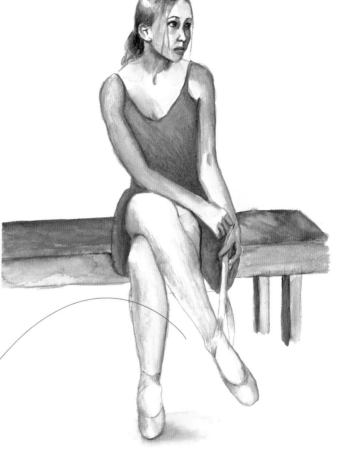

This is an extremely speedy watercolour, jotted down quickly to capture the dancer putting on her shoes. Minimal detail gives an impression of motion.

Ignore or reduce dominating backgrounds that overpower the subject

Negative shapes allow you to work out correct proportions

This cute little fellow doesn't need any detracting elements – his character is captured in a few soft pastel strokes

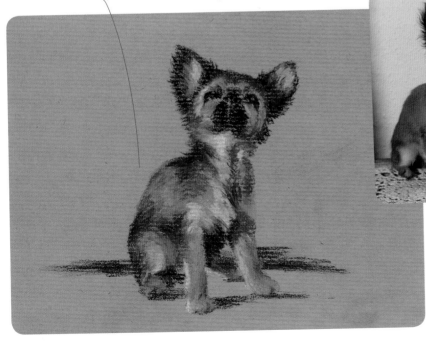

Animals rarely stay in one place long enough for a decent portrait, but several snaps of an animal as it moves about will give you plenty of reference for a painting (see page 110). This was sketched lightly and quickly in chalk pastel to capture the puppy's fluffy coat and alert pose.
(Photo by Dawn Taylor)

# Pattern and detail

There is pattern in everything; seeing it is just a matter of how you look at things. For instance, view a wicker basket from an unusual angle and you will see a repeat pattern of chequered markings; reflections make the world shimmer the wrong way round and a few fallen stones can add interesting shapes to the appearance of uniform paving slabs.

Taking photos of things that please us throws up even more of these unexpected patterns; as areas are cut off out of the frame, we see things in unexpected ways and unusual shapes and colours juxtaposed. We have probably all seen patterns in cloud and rock formations, but what about in trees, stones, buildings and crowds? In order to develop your creative eye, look for patterns and details that could add interest to your work.

## Looking for patterns

Printed or textured surfaces give wonderful interest to paintings. Contrasts between natural forms, manmade structures or small and large objects, for example, can throw out unexpected shapes and tones. Especially if they are repeating, patterns can help to describe shapes and forms. Checks, spots and stripes become smaller as they recede into the background; colours become weaker and highlights soften lines. Think about the pattern of a checked tablecloth and how it looks at the front and back of a table, or how the spots on a leopard wrap around its body and legs.

Once you get into the swing of looking for patterns and details and snapping reference photos wherever you see them, you will begin to pick out decorative textures, patterns of light and dark and attractive shapes in the most surprising places. Look out for the unexpected, such as light shining through glass, railings

> **TIP** *Leave out the lights*
>
> When painting pattern or texture, put the markings in only where the darkest tones fall. Leave the highlighted areas without any markings and the viewer's imagination will fill in the rest. This gives a three-dimensional effect and keeps the pattern lively.

*Add touches of lighter highlights to freshen the entire image*

Here the effect of man-made shapes imposed on natural surroundings creates quite a strong composition, with the wooden trellis leading the viewer's eye into the patterned shapes. Hard edges merge with soft textures and bright colours dominate, giving a balance to the painting, but also a vibrancy for which acrylic colours were ideal.

or blinds; shadows that extend across a path; a gentle breeze causing fabric to billow and furl or a familiar sight revealing a new pattern when seen from an unusual angle. Don't be afraid of ornamental fabrics or surfaces or deliberate placing of patterns. All of these can create the most interesting and worthy subjects for paintings and you only need to include the fundamental elements of any patterns.

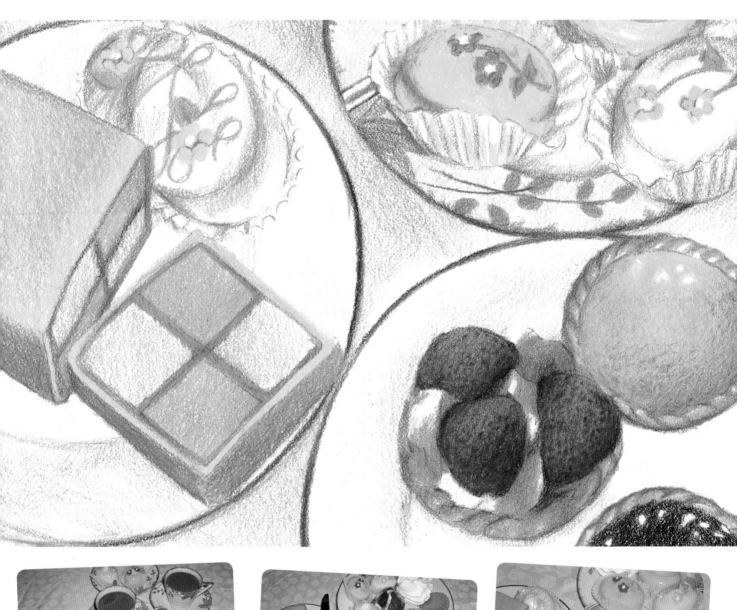

While these cakes have their own decorative patterns, the almost chance composition has a pattern to it as well.
Using coloured pencils, I tried to portray the sugary quality of the cakes and, perhaps more importantly, to reduce the
importance of tone and emphasize the colours and shapes in order to convey the pattern across the surface of the paper.
(Photo by John Hodge)

## Complicated patterns

Some people prefer to avoid painting set patterns or designs because they assume they will be difficult. However, if you deliberately seek out patterns, whether planned or chance, and then use various techniques to simplify them, you could add extra vitality to the final image.

If you wish to tackle a complicated pattern, one of the great things about having a photographic reference is that you can enlarge it by using either a photocopier or a software program. Trace off the basic shapes, then transfer the tracing onto your paper, simplifying the pattern still further but retaining the essential elements.

## Close-ups and textures

Although pattern can be shown from a distance, using largely undefined markings that convey the essence of the pattern to the viewer without actually describing it in any intricacy, there are

## Surface patterns

Pattern isn't just in colour, tone and shape – the artist can also add pattern through the handling of paint. With a thick paint, such as oil, think in terms of thick and thin applications, which you can use to draw attention to certain features. With watercolour, think about areas that bleed wet-into-wet and sections that are crisp because they are applied wet-on-dry. You can create patterns with brushmarks in paint, particularly oils and acrylics, and drawing media such as pastels also lend themselves well to describing surfaces.

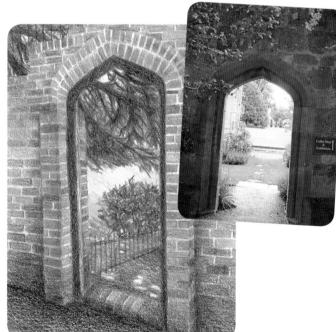

Texture and shape combine to create this unusual image, executed with coloured pencils. The viewpoint from directly above emphasizes pattern, and the unusual angle prompts the viewer to see shapes rather than identifying objects. For something such as this a random pattern works better than anything too composed, but it can also be fun to experiment with the placement of objects and lighting in order to create various patterns.
(Photo by Dave Amis)

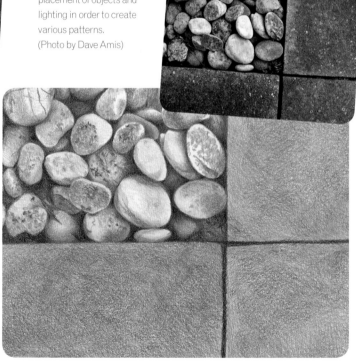

These two arches were in different locations, but I was tempted by the shapes and contrasts of each. Both the photo and the drawing (in coloured pencils) will serve for a larger-scale painting incorporating some of the particularly appealing features and patterns.
(Photo by John Hodge)

plenty of ways of building up fascinating patterns through close-ups and details. The nearer you are to a subject, the more detail you will be able to see, which opens up a range of possibilities of creating pattern. If you focus on pattern when taking close-up shots with your camera, you could find a whole new range of possibilities for painting. Colours and textures will be intensified, structures and shapes could be more intense and angles and shadows more precisely defined.

Keeping pattern in mind, allow any shadows to become part of the overall structure of your painting and refer back to the section on colour on pages 56–59 whenever you need to. Light and shade could in themselves be the subject of a painting, but in order to make this work, you will need to emphasize light and dark tones.

Finding patterns is often a question of the way in which you interpret your photos. This usually means deciding on a concept, taking some elements from the photos and then adding your own interpretation. One of the benefits of looking for patterns and textures in a scene is that it helps you to avoid the whole issue of trying to reproduce exactly what you see in the photo, which can be one of the drawbacks of using them for reference; as an artist, you should draw on your imagination to create a new picture.

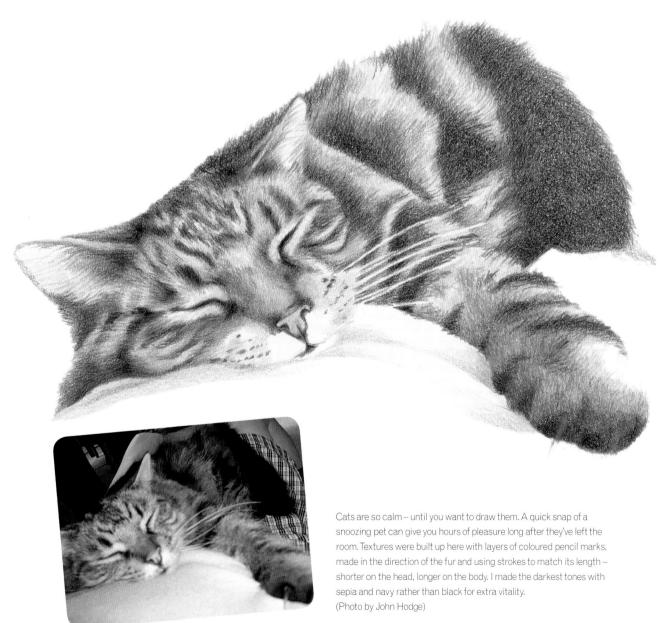

Cats are so calm – until you want to draw them. A quick snap of a snoozing pet can give you hours of pleasure long after they've left the room. Textures were built up here with layers of coloured pencil marks, made in the direction of the fur and using strokes to match its length – shorter on the head, longer on the body. I made the darkest tones with sepia and navy rather than black for extra vitality.
(Photo by John Hodge)

# Painting specific subjects

Painting isn't just about recording a scene, which is what your camera does; it's about expressing an emotional response to the subject and conveying something of that feeling to the viewer.

To do that with conviction, there needs to be something in the subject that captured your imagination, such as interesting cloud formations, a wild sea, a particular colour or a characterful face; whatever it was, retain that interest and try to make a feature of it in both the photo and the painting. Provided you've captured what you want on camera and hopefully in your memory, you will be able to translate your subject into paint.

## tip — Finding a subject

If you're not sure what you're looking for when you are out taking reference photos, take several shots of something that catches your eye – a vibrant flower, gnarled tree, striking seascape or breathtaking vista. When you get home and review your photos in a more relaxed frame of mind you may find you have exactly what you need.

## Landscapes

Landscape photos intended to act as references for painting should possess particular characteristics – check back to pages 44–49 and remind yourself of the basics of composition if you're not sure what to include and what to leave out. Look for shapes or lines that draw the eye in, around and through the scene. Ideally all your photos should have an evocative quality of light; this could mean misty rain, early dawn, bright sunshine or a rosy sunset. Finally, all photos should inspire a painterly approach – that is to say, the photo should lend itself to a painting. It is possible for a scene to make a great photo but one that won't translate well into a painting.

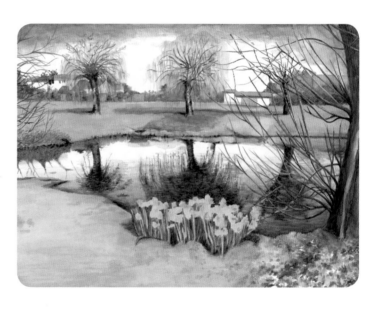

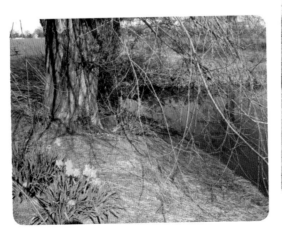

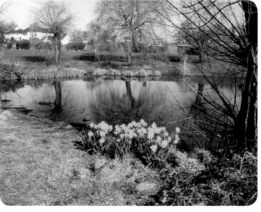

The bold contrast between the yellow daffodils and the blue behind them draws the viewer straight into this watercolour painting. Balance is achieved by the strong vertical of the tree in the foreground set against the horizontal expanse of water and by the background trees and their reflections. The foliage was built up using rich mixes of sap green, alizarin green, cadmium yellow and ultramarine.
(Photo by John Hodge)

## Painting foliage

To create the impression of foliage, build up layers from light to dark, using colours such as green gold, sap green and viridian, but don't lose the freshness you captured on camera by adding too much detail.

**1.** Start with a wash of green gold mixed with a touch of sap green. Allow to dry.

**2.** Varying the size of your strokes, randomly paint the impression of bunches of leaves in a mixture of viridian and green gold.

**3.** While still damp, work wet-in-wet, dropping in variable mixes of the three greens in different strengths. Intensify some darker areas.

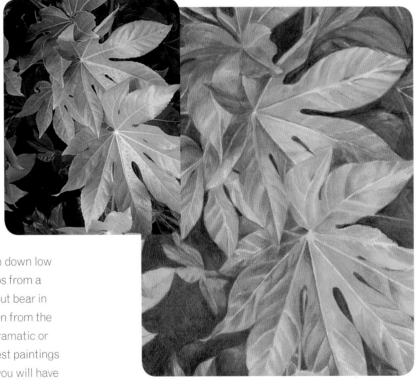

The lighting makes this watercolour and coloured pencil leaf study a dramatic picture. Without those strong contrasts of colour and tone, the foliage would not have so much interest. Note the diagonal composition, which also helps to create some dynamism in a fairly stable arrangement. Although the photo gives all the details, I only marked in the essentials, such as some of the leaf veins.
(Photo by Madeleine Nathan)

## Viewpoint and focal point

In choosing a viewpoint, try to imagine how the composition will look as a painting. One of the benefits of photography is that you can choose any viewpoint you can reach, even if it isn't somewhere that would be comfortable to paint from. If you need to, climb onto a wall or crouch down low in order to get the best shot. It's natural to take photos from a standing position without considering alternatives, but bear in mind that exciting pictures are not always those taken from the expected viewpoints. Having said this, don't adopt dramatic or unusual viewpoints for the sake of it – some of the best paintings arise from conventional angles. It is something that you will have to weigh up each time.

Attention is always drawn to extremes of contrast where lights and darks meet. This is also often the focal point of a picture, such as the daffodils in the painting opposite; limiting combinations of light and dark to one particular area will attract the viewer's eye. Before you begin a painting with this idea in mind, decide what your main point of interest is. Start by identifying the lightest and darkest colours in your picture to give yourself the best chance for a strong composition. Block in large areas of colour, and then build up mid-tones for structure. Next, paint small, darker details and finally add tiny amounts of pure bright colour and the darkest accents to make the focal point apparent. (See the step-by-step project on pages 80–87.)

## Flowers and foliage

Outdoors, think of these subjects as mini landscapes or as portraits (see page 71), depending upon how close you are to them. However, if you are dealing with cut flowers and foliage in a vase, they fall more into the category of a still-life subject (see page 70). Pattern is important here, not just in terms of the markings on petals or leaves but also the patterns made by the way they interrelate (see pages 64–67).

Before you take your reference photo, half-close your eyes to help you make sure that the colours don't merge into one colour or tone and that the main features can be differentiated. You can see a flower painting built up step-by-step on pages 88–93.

## Still life

Still-life subjects are usually painted from direct observation, but photos can be used at leisure to help you to decide what you want to include or omit. Light is often a large part of a still life, and as the angle of natural light will change during the day it is very useful to have a photo as a fixed point of reference from which to work out the balance of solid objects and less tangible elements in your painting. Photos are also useful if the subject is liable to change – flowers may wilt, for example, or fruit may lose some of its gloss.

### tip    Natural light

People usually look their best in soft natural light, perhaps under the shade of a tree or by a window. If it's too dark, you can reflect some more light onto the face using something white or shiny, like foil. You'll have to play around a bit with this until you get the right effect. If conditions are too bright, either seek out a better location or create your own shade, perhaps by taping white paper against the window.

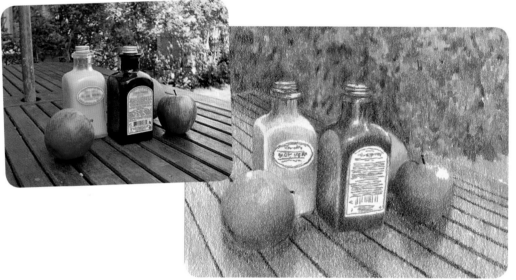

Here I wanted to differentiate the picture clearly from the photo, not in composition but in terms of treatment. I used small, sketchy, vertical marks with coloured pencils to create an almost shimmering effect, much like an Impressionist painting.
(Photo by John Hodge)

## Animals

It's not always possible to observe and draw animals at leisure. Whether your subjects are pets or animals in the wild or in zoos, they can be tricky because they are often on the move. In addition, errors of draughtsmanship are often more apparent because we all know what a cat or a lion should look like, for example. Not only do you have to make your animal look convincing, you also have to apply the same considerations as you encounter with any other subjects – composition, lighting and colour.

If you're on safari or in the countryside you will need a zoom lens to get the animals large enough in the photo to give you a useful reference, and a zoom can also be handy for wild birds and pets because it enables you to keep yourself at a distance while still capturing the detail. Surprisingly, the majority of animals are undisturbed by flash, but if you feel your subject may leave at speed and you will lose your shot, make sure your flash won't come on automatically.

Photo references can help with your animal paintings in a number of ways:

• They help capture personality, especially if you catch the animal at play.

• They give you the ability to study details such as eyes, fur and scales.

• By studying a series of photos you can learn how animals move their limbs, stoop to drink or feed, stretch, groom themselves and so forth.

• You can study shadows and highlights on glossy coats and see how markings follow the contours of the body as an animal moves.

As usual, remember not to copy your reference photos slavishly. Think about simplification, and, to give the painting verve, use a wider range of colours and tones than is present in the photos. For further guidance, see the step-by-step project on pages 110–117.

# Portraits

Although a great many portraits are painted from photos, as these help the artist to study the shape of the features, nuances of expression and skin tones, they can often appear to be stilted and unnatural. This is primarily because many photographic portraits are taken with flash photography, while the subject sits or stands awkwardly, grinning fixedly at the camera. Flash flattens faces and puts shine in awkward places, so where possible, use natural light from a window instead when you are taking photographs indoors (see tip, opposite).

This quick portrait was painted in oils on oil painting paper, using just three primary colours and white. It's best to refrain from using black when painting portraits of children; it can have a somewhat deadening effect, which mixtures of tertiary colours avoid.
(Photo by John Hodge)

A photo allows you to understand an animal's personality, to see any unusual markings clearly and to be able to paint in peace without either sitter or artist becoming stressed. For this boxer dog I used chalk pastels.

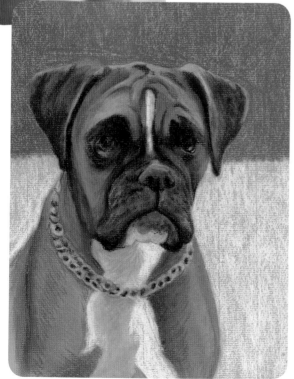

Face-on, posed positions often seem contrived and don't show the person's character, so it is better to take a few informal shots when the sitter is relaxed and comfortable. If your models can't seem to resist striking poses, ignore them for a while or change the subject of conversation, then snap away when they start to act more naturally.

Think about viewpoint, as this will make a difference to the perceived personality of your subject. Looking down on someone forces them to look up, often making them appear vulnerable, while looking up at a subject can give them an air of aloofness. You can also convey personality through your use of colour and texture, and sometimes by the position or action of the subject in the painting – see the step-by-step portrait on pages 118–125.

# Becoming creative

The expression 'use your imagination' puts fear into the hearts of many people, whether experienced artists or complete beginners. However, photos can be a brilliant means of stimulating inspiration and creativity.

Use your photos as a basis from which to layer colours, lines and patterns and to explore blurring and smudging, overlapping and stretching of shapes. Not all artists are inspired by the same things and one photo has the potential to generate hundreds of different ideas depending on our own experiences, backgrounds and moods. The following pages will hopefully suggest some different ways of thinking about familiar subjects and alternative approaches to working from photos.

Start with something that inspires you, whether for the colours, shapes, mood or linear qualities and, if possible, photograph it several times. Fruit, flowers, trees and other

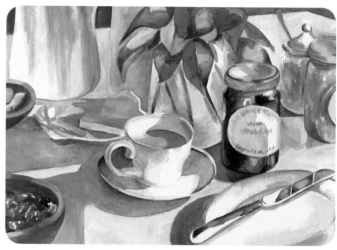

As the photo is of a mundane, familiar scene I decided to emphasize tones and subdued hues to create something a little more unusual in my watercolour painting. The glass and china reflect the bright morning light shining on to the table and the cast shadows make wonderful shapes. Notice how cropping in on the table has helped the composition.

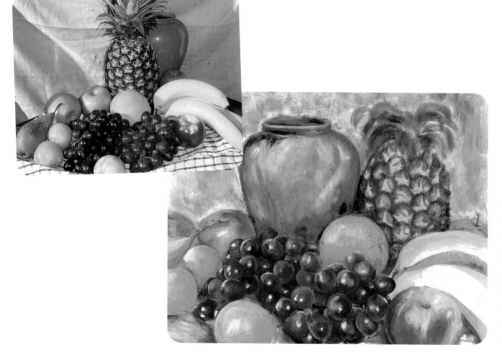

As a change from the straightforward representation of this arrangement of fruit on page 56, here it was built up using additions of scribbled felt tips and thick acrylics. I began by painting everything in perspective and from one viewpoint, then blurred and merged edges by saturating the surface of the paper.
(Photo by John Hodge)

natural forms can all be manipulated and distorted using the basis of colour, pattern, texture or forms.

A still life of fruit is a particularly good subject to start with. Complementaries – colours opposite each other on the colour wheel – naturally present themselves in juxtaposition, such as the green and orange-red of an apple or the contrast between yellow bananas and purple grapes, so all the colours are enlivened. The forms are also usually straightforward, so you can get straight down to your interpretation.

There are endless ways of tackling the same subject and arriving at completely different outcomes. Start by looking at your photo and 'pulling out' a character or style from within

yourself to alter the straightforward image before you. Keep your artist's eyes open and you will begin to notice happy accidents in placement and start thinking of original ideas and combinations of objects. If you start without any preconceptions you can combine crisper shapes with softer 'lost' edges, for example, to give a very different and perhaps surprising appearance to your subject. Try painting it from different viewpoints as the Cubists did, or change local colours – the true colours of objects – in the style of Fauve painters such as Henri Matisse.

It can be great fun playing around with angles, sizes and application to produce your own personal interpretation of a subject, especially if you accept that your first few attempts might not go according to plan! It's only after a lot of experiments and accidents that most artists find their individual style.

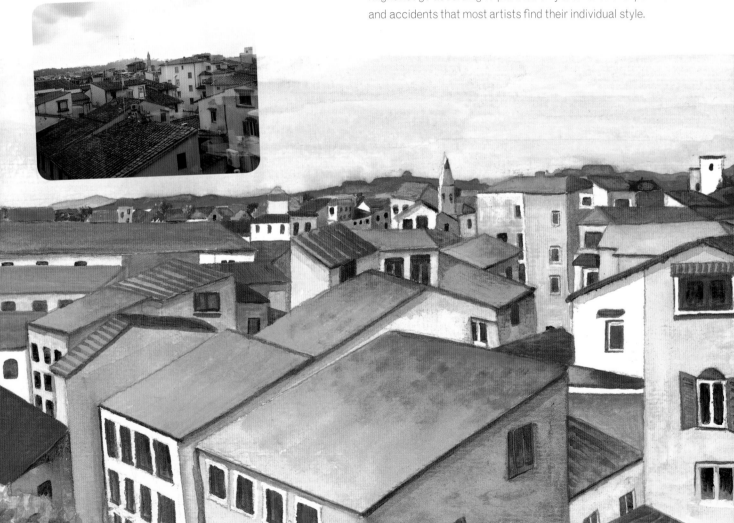

The composition of this painting of Florentine rooftops essentially remains the same as that of the photo, but I went for an illustrative approach, using flat colours, geometric shapes and lines and thin washes of acrylic paint. The resulting painting has an almost diagrammatic or children's-book style about it.

## Moving to abstraction

Abstract art has nothing recognizable of the real world in it. Abstraction, on the other hand, is the distortion of real-life representation. You can start turning your paintings into abstractions by beginning to loosen your style, by 'losing' hard edges, by changing colours or by eliminating outlines or contours, perhaps ending up with a composition of colour patches or layers of images in different media. From the elementary shapes that are still apparent, the original image can be worked out in the viewer's mind.

Using photos as a strong visual basis, you can push your ideas, mixing media or simply trying out new effects and taking risks. The best piece of advice if you want to try abstracting your work is to be confident and experiment. Don't be afraid of mess, mistakes or even getting into a muddle as you try out various methods. The whole point of this approach is to see it as a challenge and go for it. Even if you decide it's not for you, it is a way of learning about the limits of materials and of your intentions. The greater the risks you take, the more rewarding will be the results. If you want to push this further and move towards complete abstraction, try breaking down elements in your photos to their most basic shapes, or basing your piece on an idea more than on solid objects and making the idea the subject.

Begin with one or two photos of a naturalistic image. The process of abstraction is in the way in which you transform your painting into an unrecognizable composition. You will probably wish to retain a connection between the photographic reference and the final painting. Although it might not be apparent, what will be common to both the photograph and the painting will usually be the inner structure or idea. Abstraction is a process through which accidental features are discarded until only the essential idea remains. This idea is expressed through the way in which you apply paint, pastel or any other medium. If you allow yourself to experiment, a whole new world of opportunity will open up. You probably won't want to abandon your customary methods, but you should be able to find ways to explore the familiar paths in unexpected ways.

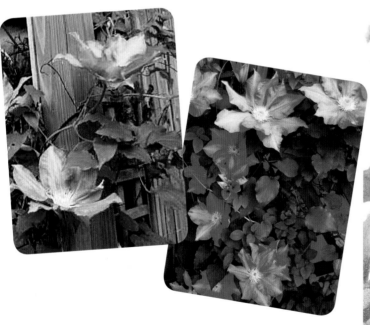

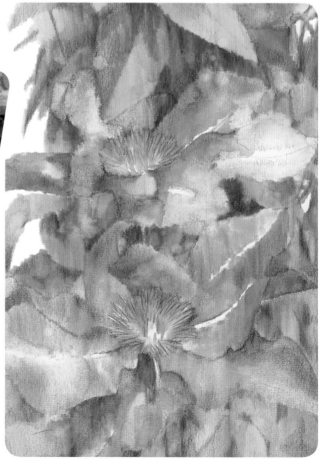

This painting is moving towards abstraction but is not there yet. The ethereal approach was achieved by light, feathery, vertical watercolour pencil marks. I diluted the marks with drips of clear water and blended them here and there with a piece of soft kitchen towel. In some parts of the picture the pencil textures are still visible, while in others water has softened and merged them.
(Photograph by John Hodge)

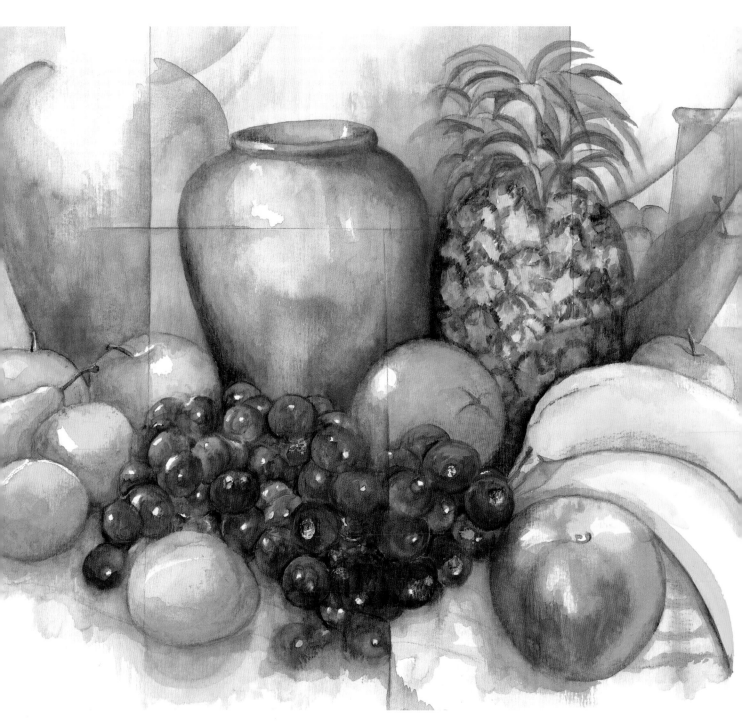

In this version of the subject on page 72 I began by drawing the outline in pencil on paper, dividing up the drawing with a light pencil grid on top. I then started painting in watercolour, allowing the washes to run into and overlap each other. When it all began looking too orderly, I dropped water onto damp paint and merged colours into each other. The hinted reflections and shapes give an illusion of something else going on rather than just one clear-cut image.

## Bringing colour into monochrome

If you have some old black-and-white or sepia photos, start sifting! You never know what you may uncover – some gems from the past or something that has sentimental value for you or another family member or friend. Because of the absence of colour, monochrome photos reveal tonal values clearly, simplifying the image, which means that half your work is done for you. Before you've even started the painting, you can plot where to put the darkest darks and lightest lights.

Translating black-and-white or sepia images into colourful paintings requires some sensitivity, but don't be put off making your version vibrant if this is appropriate. To reproduce a sepia image as it looks, use a range of colours that, when mixed, appear overall to be monochromatic, but have greater scope than that. For example, build neutral tones using combinations of reds and greens or blues and oranges. In watercolour, Prussian blue and cadmium orange or purple lake with raw sienna result in interesting browns, while with oils and pastels, try sap green with rose madder or ultramarine with yellow ochre. In this way, you will build up a depth of colour that infuses liveliness into old photos. Of course it's all down to interpretation, but painting from old photos, whether retaining the original monochrome or translating them into glorious colour, is a satisfying way of bringing the past into the present.

Look through old boxes or drawers of photos and see what you can find. Pictures from the past make an excellent basis for nostalgic paintings that could awake memories for the viewer.

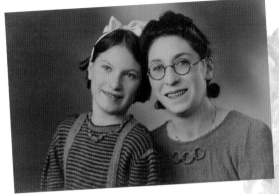

In the oil painting right, I used a range of colours for the flesh tones and built up the lights and darks. This was a quick, sketchy portrait, but you could spend more time and produce something with greater detail and depth.

Another quick painting, this time in watercolour, captures the mood of the photo. As is often the case with older photos, the detail is not clear; I was keen simply to inject some colour into an image that has always made me feel happy when I look at it.

# The projects

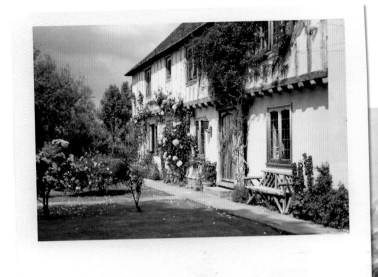

The following pages show a selection of
step-by-step paintings that were created
from photo references. They use a wide
range of photos, subjects and materials,
showing the various effects that can
be achieved with different mediums.
It's helpful to see how the paintings
develop, as you can either follow the
steps yourself or use the information
and guidelines to inform your own work.
Treat them as practical workshops,
showing you creative processes from
photos through to finished paintings.
There are tips on using acrylics,
watercolours, coloured pencils and oils.
Subjects include landscapes, buildings,
figures, flowers, still life and animals.

When photographing and
subsequently painting houses, try
unexpected viewpoints to capture
their angular aspects and contrasting
materials. Either stand on something
or take shots from a crouching
position. Alternatively, try taking a
picture from a dramatic side view.

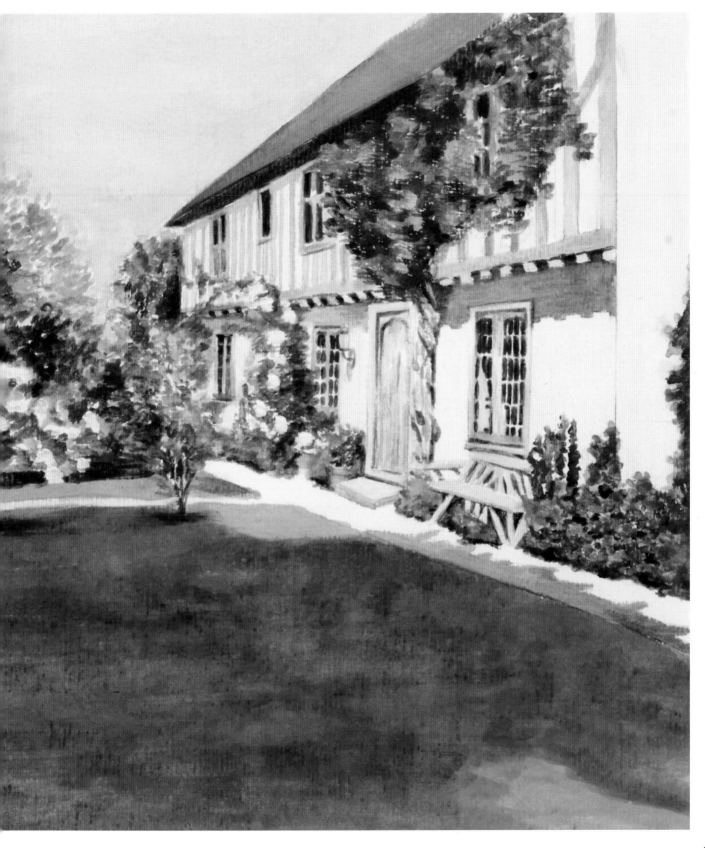

# Landscape

Landscapes are one of the most popular subjects for amateur artists. No matter where you live, it is always possible to find a scene worthy of a painting.

Locations near your home have the advantage that you can revisit them at all times of day and in all weathers, while holiday photos will provide you with reference material for paintings that will evoke your travels long after your return home.

It's a good idea to analyse exactly what appeals to you about a particular scene. Remember that landscape painting is as much about atmosphere as it is about actual objects, so you can accentuate any aspect in order to create the spirit of a place.

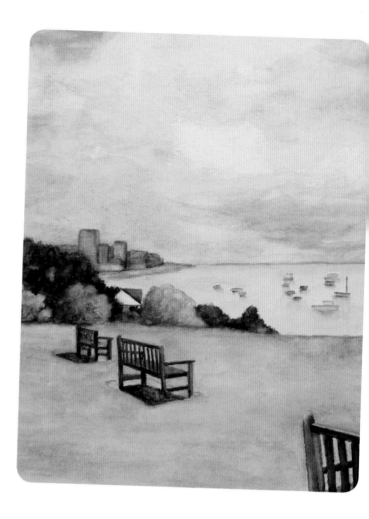

**tip** **Using the camera's viewfinder**

Your camera's viewfinder is a ready-made frame through which to look at a composition. Our eyes see a wider expanse than a standard lens, but the viewfinder helps you to focus on the area you will be painting.

## Using a camera

Most landscape painters use cameras to a greater or lesser extent. One of the greatest advantages of doing this, of course, is that photographs can capture a fleeting moment, retaining sunlight, shadows, cloud formations and so on. Photographs of scenes also give you time to contemplate – to study shapes, forms and colours, without weather, nightfall or interested onlookers interfering.

Sometimes you can manage to get the scene you want in just one picture, but you can also build ideas for different effects by taking a number of photos. Later you can enhance or alter colour either on the computer or in your painting, if you wish. Consider the balance of the composition and whether you can improve it by adding or removing features, emphasizing pattern, allowing occasional strong features to dominate and counteracting others. It's difficult to be specific as everyone has their own ideas, but the best advice I can give is to be open to adventure and to try out various ways of working until you find an interpretation that you are happy with.

## Lighting and mood

The mood of your landscape will change depending on the weather and time of day. Morning light casts long shadows and strong contrasts, late afternoons often bathe scenes in warm golden light, and midday can either throw out intense shadows or alternatively hardly any at all, depending on your viewpoint. Within a landscape, gradation – the use of graded tones of one colour – emphasizes both perspective and unity. Use gradation to add interest and aerial perspective and to lead the viewer's eye into the painting.

*Look out for angles and curves – some are subtle, others are more dramatic*

*In the photo, the horizon cuts the picture in half. Consider moving this in your painting*

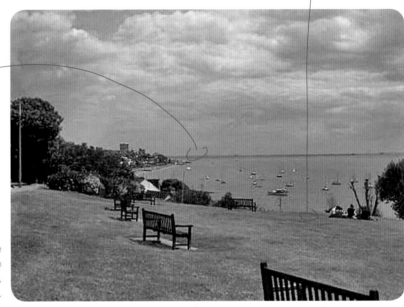

Be selective about what you include and what you leave out. You want to hint at boats, benches and buildings, not crowd your painting with them.

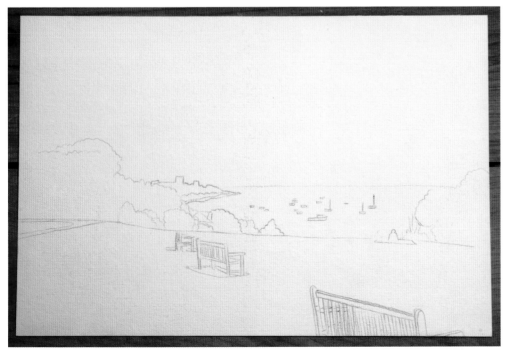

A sketch enables you to confirm exactly what you want to paint and where to position the main features. In a scene like this, you might want to give more space to the sky or to the land. To me, the sky is so important when painting sea, lakes or rivers that I knew that it would need some emphasis in the painting – just enough to add interest, but not so much that it overpowered the scene.

## Summer cove

A beautiful summer's day, with the sea glittering below and picnickers out enjoying the sunshine, was too good a subject for a painting to miss. I wanted to catch the sweeping bay and boats bobbing in the distance, but also to contrast it with the verdant foliage in the foreground and the distant buildings, so I walked about a bit, taking shots of various vistas.

I took several supporting photographs for this painting. I altered my eye level as I took the shots, but focused each time on what attracted me in the first place – the calm, glittering water far below.

## Planning the composition

Once you have selected the main aspects that you want to include in your landscape painting, it's helpful to take some supporting photos from different vantage points and use these like sketches. Of course, you might want to make some sketches too. These will help your hand get the feel for the forms and, if you are planning to use elements from different photographs in your painting, they will enable you to see whether the composition works.

Even if you do not paint directly from any of the supporting photos, they will help you to see what's important and to understand the positions of objects, elements and features. When you come to paint the landscape they will also remind you what grabbed your interest in the first place, and will help to establish the prevailing mood of the scene. Essentially, when I'm painting, my photos all act as reminders to me of the atmosphere and overall feeling of the landscape as well as giving me information about structure, shapes and shadows.

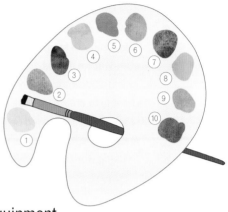

### Palette and equipment
- **Artist's quality watercolours:** (1) cadmium yellow, (2) ultramarine, (3) leaf green, (4) sap green, (5) viridian, (6) cerulean blue, (7) cobalt blue, (8) raw sienna, (9) light red, (10) burnt umber
- **Pencils:** B or 2B
- **Brushes:** Medium (No. 8) and small (No. 2) round brushes
- **Surface:** Bockingford 300gsm (140lb) HP surface

## Painting the composition

The limited palette I used helped to create a harmonious interplay of light and shade. To start, I used a soft pencil to sketch in the main features, making sure the composition filled the paper as I envisaged it. By doing this, you can erase and adjust any aspects before you start painting.

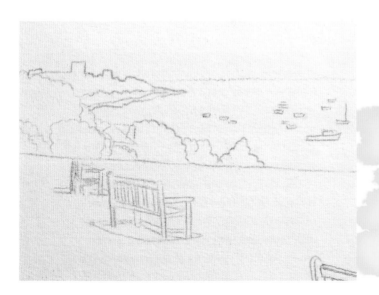

**1.** Lightly draw the basic elements of the scene with a fairly soft pencil, such as a B or 2B. Make sure you've put the horizon in a 'comfortable' place, giving you enough space for sky, but not too much or you'll risk making the sky the focus and not the land and sea below. As you draw, look out for patterns made by the sky, sea and land forms, but don't put in too much detail.

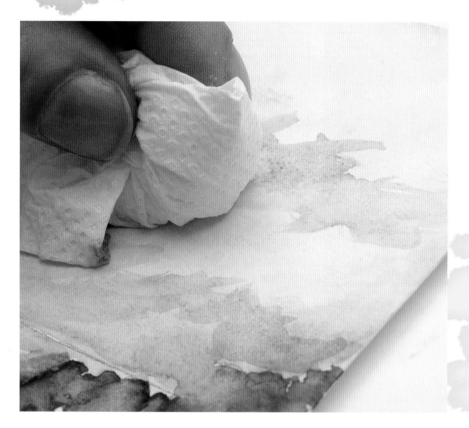

**8.** Strengthen the sky with some rich washes of ultramarine and cobalt blue, using the No. 8 brush. While this is still wet, scrunch up a piece of kitchen towel and dab the sky here and there in small, circular motions to create the impression of clouds.

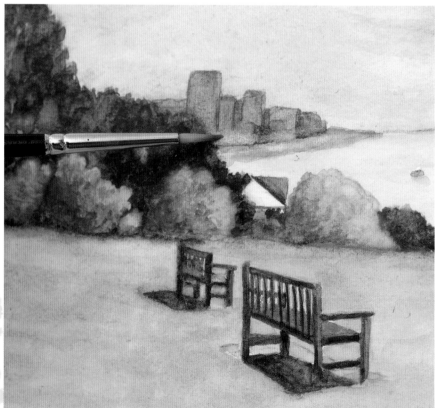

**9.** Keep your brushstrokes loose and horizontal as you build up the foreground grass with greens made up from mixes of cadmium yellow, leaf green and cobalt blue.

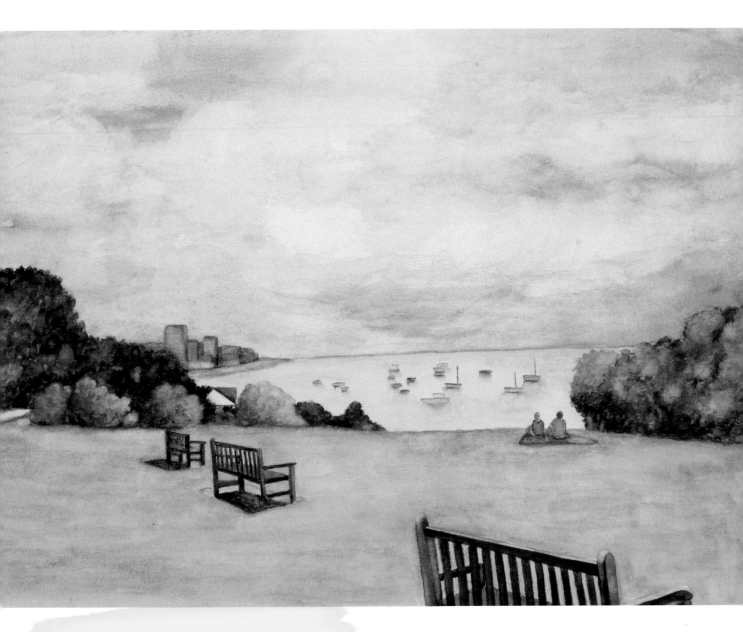

**10.** Add a few touches of stronger ultramarine and burnt umber to the background buildings, using the same colours for shadows under the bushes and trees. Paint the sand with a light touch of cadmium yellow and raw sienna and continue strengthening features and refining details.

# Flowers and foliage

If you have ever tried to paint flowers from life, only to find that while you work buds have unfurled or open blooms have begun to droop, then you will appreciate the advantages of using photographic references to work from instead.

Taking photos of flowers enables you to paint them whenever you want – you don't have to try to finish your painting while they are still fresh. Nor do you have to paint only in the summer months when most flowers are at their best – you can keep a store of flower photos to paint at any time. Take lots of flower shots in the garden, on holiday or wherever you see a splash of colour that inspires you.

Garden flowers are a delight to paint, especially if you have grown them yourself, but cut flowers work well too. Even a bunch of flowers casually arranged in a vase will often produce an instant and spontaneous result that you can interpret in a lively, loose way or with a more controlled and careful approach. Choose chunky glass, an old terracotta pot or shiny patterned china to display your flowers.

To get the best effects, keep backgrounds and any surrounding details simple. Any adjacent objects must enhance the flowers and not attract attention away from them. Dark backgrounds, reflections, patterns and lights and darks can all be used to unify the paintings, but make sure that you don't overload any of this and so undermine the flowers, which should be the dominant feature.

 **Flower photos**

It is usually better if you can take your own photos to refer to as that way you will know what you were originally attracted to, and can try to recapture that in your painting. Flower images are also plentiful in magazines and books and on cards, so if you see a photo that inspires you, paint it, but change it so it's yours and not a copy.

## Simplify your subject

One of the problems with painting from photos rather than from life is the tendency to try to include everything that appears in the photo. It's all too easy to overload a flower painting, as even the most robust needs still to be quite delicate. Remember that less is nearly always more and make a decision about what to include and what to leave out. Ultimately, your painting will be judged by its attractiveness rather than by how accurately you have interpreted the source material. One of my favourite ways of painting flowers is in big, bold, Georgia O'Keeffe style, as in the painting of the roses on page 42, for example. To do this from photographs, use any photo-editing software to zoom into a small area of a flower photo.

Try to work quickly and allow your paper to show through for added 'zing'

A light touch and clean colour is needed to capture the vibrant hues

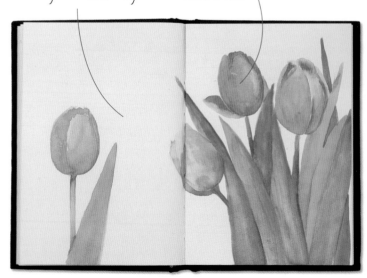

Don't neglect your sketchbook. Even quick paintings and sketches help you to get your hand in, and watercolour sketches provide an opportunity to experiment with colour blending.

## Two roses

Of all my rose photographs, the one I decided upon attracted me the most because of the colours of the blooms and the symmetry of the composition. I rarely place flowers right in the centre of a picture, although this is certainly not a rule. If a flower seems to need to be centre stage, then that's where it will go!

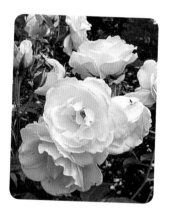

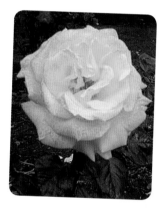

When you are inspired by a particular plant, such as roses, take a number of different photos so you have plenty to choose from. With flowers you also have scope to compile the best blooms from several photos into one group for your painting.

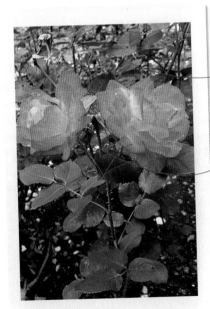

*An asymmetrical composition draws the viewer's eye around the picture*

*The diamond shape in the centre will have to be altered in the painting, to remove the 'hole'*

Ultimately this is the photograph I chose as my reference. I like the way that the colours blend from yellow through to peach and pink and the way the blooms face outwards, as if giving of themselves.

Begin with a light pencil sketch. You don't have to mark in every last detail – indeed, if you put in too much it will simply get in your way – but it is useful to plot the sizes and positions of the main elements as well as any other details that you think are important or problematic. Concentrate on the flowers without paying much attention to the surrounding leaves.

## Painting the composition

For this painting, I used a No. 8 round brush with a good point, which allowed for delicacy and detail without forcing me to overwork. In the chosen photo the flowers are a natural focal point – their vibrant colours make them stand out from the background. Notice how in the finished painting on page 93 the tonal differences in the flowers have been exaggerated in order to create a strong contrast that draws the eye even more.

The foliage is so busy that it would not only be difficult to render exactly but would actually detract from the painting, so this area can be safely simplified.

### Palette and equipment

- **Artist's quality watercolours:** (1) lemon yellow, (2) cadmium yellow, (3) leaf green, (4) Hooker's green, (5) alizarin green, (6) viridian, (7) cobalt blue, (8) ultramarine, (9) cadmium red (light), (10) vermilion, (11) permanent rose, (12) raw sienna, (13) rose madder, (14) dioxazine violet
- **Pencils:** B or 2B
- **Brushes:** Medium (No. 8) round brush
- **Surface:** Bockingford 300gsm (140lb) HP surface

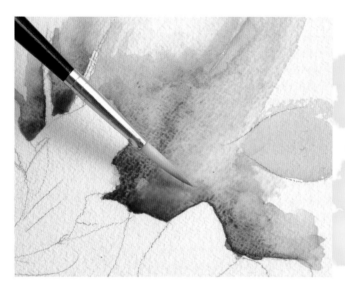

**1.** Having made your initial sketch (see page 89), dampen the paper around the roses and drop in some Hooker's green, ultramarine, cobalt blue, alizarin green, leaf green, viridian and lemon yellow to give a hint of leaves and stems but no specific details. Close to the rose petals, the deeper greens are made with more blue. If you find you've covered the stems with too much colour, lift it out with a clean, dry brush.

**2.** Check that the edges next to the rose petals are dry and then, using a clean brush, flood the petals with cadmium red (light). Don't worry if the green merges with the red in some places, as these 'accidents' give a softer, more spontaneous final image. Allow the colours to merge into each other by adding clean, clear water as necessary.

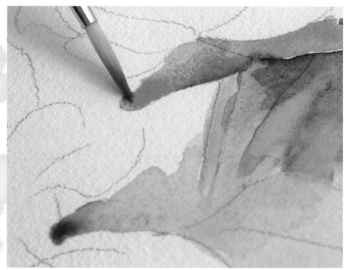

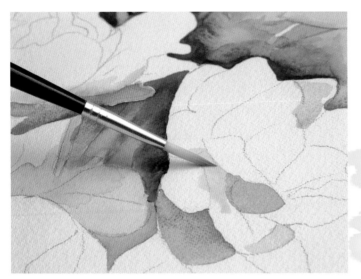

**TIP** *Know when to stop*

Viewers will imagine much more detail and description than you need include in your painting, so resist the temptation to keep adding more and more.

**3.** Working over the petals wet-into-wet, paint varying mixes of cadmium red (light), vermilion and rose madder. Check each petal in the photo for variations in light, tone and colour, diluting or deepening the paint as necessary.

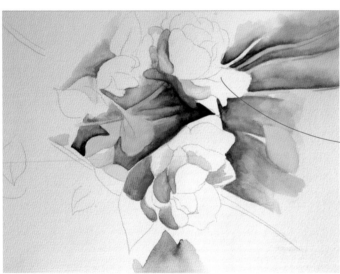

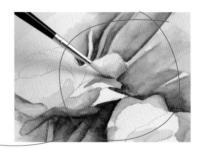

**4.** Add small, local areas of dioxazine violet, ultramarine and lemon yellow in the darkest parts of the composition, then carry on with the red of the petals.

**5.** Work across the painting, strengthening some patches of foliage. Do the same to build up the petals, loosely applying rose madder and permanent rose in the deepest pink areas. Keep an eye on the patterns forming across the painting and comparing them with those in the photo. From time to time stand back and appraise the balance of tones and colours in the painting as a whole. Check that the shapes are starting to appear.

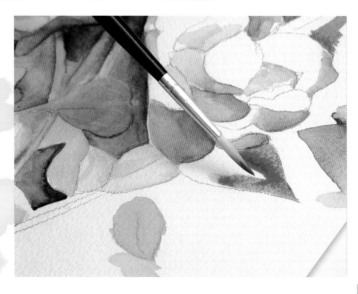

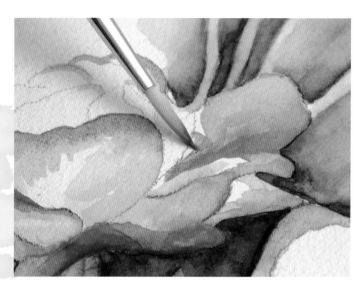

**6.** As the petals dry, add more colour where needed and apply further, softer washes. Flood in deeper red where the deepest tones appear. The speed of painting wet-into-wet is ideal for painting organic objects such as flowers. Use light, broad strokes, some wet-into-wet and some wet-on-dry to 'lift' the colour.

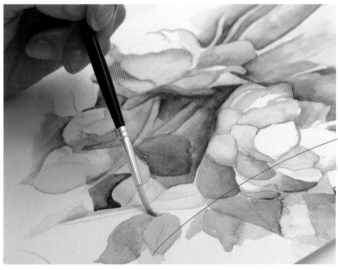

**7.** Move back and forth from the background to the petals, checking the balance of colour, tone and pattern. Create a general idea of the leaves and stems with varying colours and shapes. Add raw sienna to the shadows around the leaves.

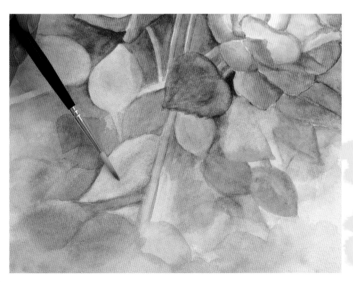

**8.** Add cadmium red and permanent rose to the petals and then add rose madder to the wet areas. Strengthen the shapes of the leaves and stems, softening some areas with a clean brush or dry kitchen towel to vary the tones if you need to.

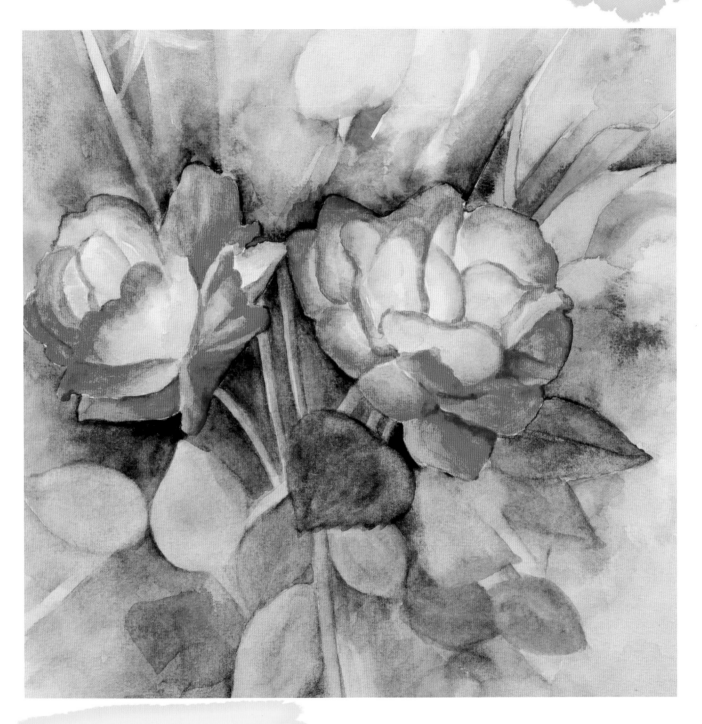

**9.** Deepen the petals where necessary with permanent rose. Apply cadmium yellow and lemon yellow to the lower parts of petals and build up depth in the shadows and leaves with delicate touches of raw sienna, cobalt blue and ultramarine, using only the tip of your brush.

# Still life

One of the delights of painting a still life is that you can compose a subject from everyday objects and take complete control of it. Not only can you select and arrange the objects but you can organize the lighting as you want it.

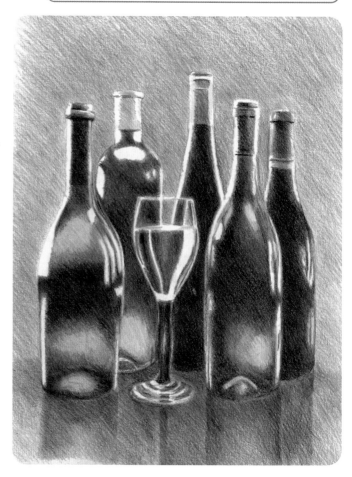

*Wear your artist's thinking cap at all times. Start to really see the things around you. Think about the colours and compositions of groups of objects that seem to work well together. This is not only good practice, but you will never be short of ideas.*

Sometimes you can work directly from your set-up, but even when you are indoors the lighting may change and your subjects may alter: in particular, flowers may open or start to fade and food items won't last indefinitely. In addition it's not always possible to leave a still-life arrangement in position for as long as you need unless you are lucky enough to have a workroom or studio. This is where photography can come to your aid yet again.

As usual, take several photos from different viewpoints. Try out different lighting arrangements too, and move the items around to see how this affects the balance of the composition and the way colours look when placed together. Close-up detailed photos will help you to add realism to your painting, so see what your camera will allow you to do. You might want to select one small area of a still-life photograph and enlarge it greatly to use as a reference. Experiment with different crops on the computer to see what works or make some quick thumbnail sketches.

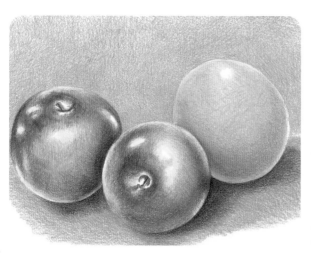

A photograph of a simple study of fruit proved helpful in terms of lighting, positioning and the condition of the fruit. This still life was strongly lit with electric light from above and natural light from the side, causing colours and shapes to reflect on different surfaces.

The effects of light on the glass were so intriguing that the unplanned still life above just had to be captured! Using coloured pencils in a broad range of hues, I played around with colour blends and contrasts to enhance the effects of light and reflections.

# What to paint

Because you can choose whatever you want – or have to hand – for your still-life arrangement, it can sometimes be difficult to make a final decision about what to include. Try not to get too anxious about the idea of creating the perfect set-up; you will have many chances to set up other arrangements and it is often the simplest, most everyday items that make the best pictures anyway. Here are some suggestions.

• Keep your eyes open all the time. A chance finding, such as a just-finished meal or assortment of child's toys can make a great painting, while an array of fruit or gardener's discarded tools can have a charm of its own. Never dismiss anything as too mundane – it's how you paint it that counts.

• Look at the work of other artists and see what subjects you find most appealing. See if you can set up something along the same lines.

• Think about natural groupings. A bowl of fruit, an arrangement of paper, pen and ink or clothes on a clothes line look 'right'. But if you gather together your favourite ink pen, a nice orange and a pair of gloves the viewer will find the odd assortment rather unsettling.

• Put together items that say something about you or your hobbies. If you like to knit, for example, include balls of wool, a knitted sweater and your needles. If you are a keen gardener, gather some pots, plants and a fork. You can even paint some of your art equipment.

• Think about how objects relate to your style of working. If you like to work on intricate details, then a beautiful china figurine might play a good part in your still-life arrangement, but if you like to work with big blocks of colour then the same item might not work so well.

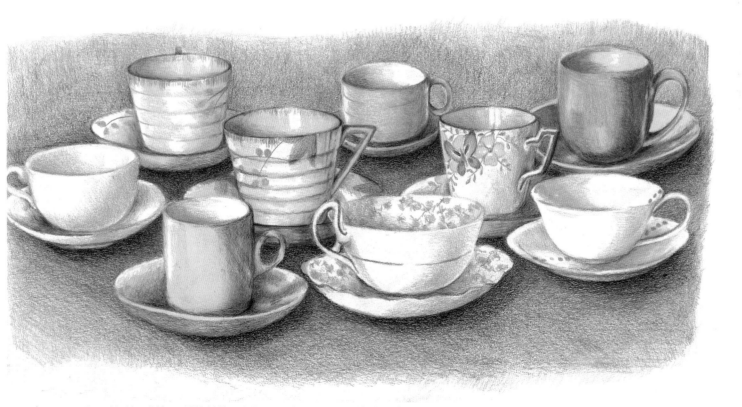

Any non-moving subject is valid for a still life! Although this image has a regimental feel to it, the composition is asymmetrical and attention has been drawn to pattern – between the coffee cups and saucers as well as on the crockery itself. Even tonal contrasts create patterns across the entire image. To pull the picture together, I used complementary colours in the shadows and echoed some colours across the picture. For instance, the green on the green cup has also been used in some of the foreground shadows.

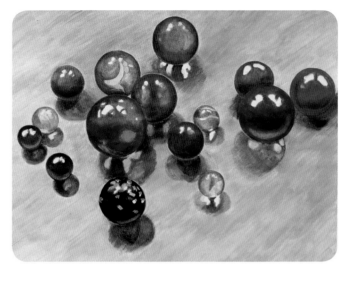

## Marbles

This simple still-life set-up shows that you don't need to have fancy objects in a painting to make it work successfully. It's the sort of arrangement that you may have come across any day of the week if you have children or grandchildren. I chose marbles for their jewel-bright colours and the way the light shines through and between the glass orbs. The arrangement has continuity because the marbles are connected by their shadows and reflections.

## Taking and editing photos

Some subjects are easier to photograph than others. These marbles were not quite straightforward because they are both small and shiny. It was important to turn off the automatic flash for the photos because the light would have bounced right back off the marbles, obscuring detail and washing out the colour. It was also the reflections and shafts of coloured light shining through the glass marbles onto the wooden surface that particularly appealed to me. One photo was too blurred to be useful and others did not allow for much overlap and colour exchanges, so in the end I used only one picture for reference.

## tip Photographing glass objects

We are traditionally told to take photographs with the light coming from behind us. With glass objects such as marbles, you'll get a much better effect if the light is coming towards you or from one side. The lower the light source, the longer the shadows or cast light will be, so if this is what you want to concentrate on, either position your objects where a window conveniently lights them or consider using artificial light to achieve the right effect.

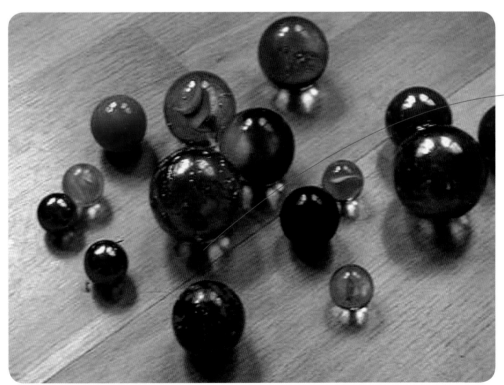

*I liked the way the light shone through the marbles and 'painted' the wood with their colours*

The wooden floor is neutral, keeping the attention on the subject – the marbles. Had they been on a white surface, the colours and shadows would have been too strong for my liking. Although the marbles are not completely in focus, I had all the information I needed – form, colour and areas of reflection are all there. I knew I could also refer to the marbles directly if I needed to.

## Sketching the composition

I made a couple of quick pen sketches to establish ideas in my head about composition. Some drawings from direct observation also enabled me to become familiar with the way in which the light shone through the coloured glass and reflected it onto surrounding surfaces as well as other marbles. I tried using a variety of materials, from coloured pencil, to chalk and oil pastel, each giving me useful information about the subject. In the end, I chose to use acrylic paints to render the juicy, vivid colours of the marbles.

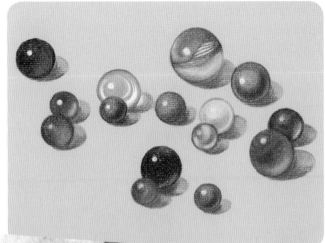

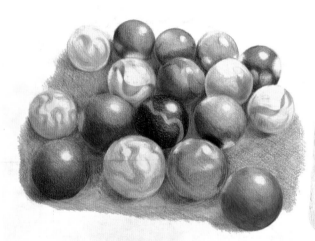

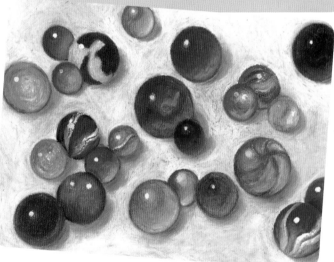

It's always advisable to do some sketches before you begin your painting. This loosens your hand and enables you to check the composition. You can also use it as an opportunity to experiment with different media. I used chalk pastel on pale brown Ingres paper for the version top right; oil pastel for the image above right; and coloured pencils for the version above.

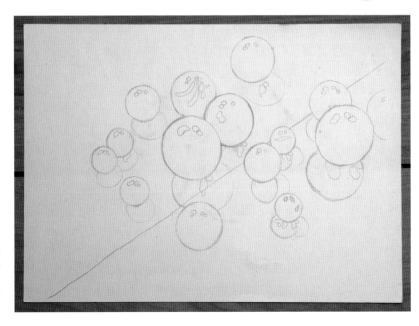

Begin with a pencil sketch, using a soft 2B pencil and marking in the positions of the marbles, highlights and shadows, paying attention to relative sizes and distances. Don't just look at the shapes of the objects themselves. Study the negative shapes – the shapes between objects – because this will help you draw the actual objects accurately.

## Painting the composition

I chose to work in acrylics because they have the bright colours and good covering power that suits this particular subject, though gouache or oils would work equally well. I worked on 300gsm (140lb) acrylic painting paper, using a mix of thicker-bodied acrylics and 'normal' acrylic paints. For the most part I diluted the paints to achieve a good flow of colour, but you can also experiment using them straight from the tube or mixed with a thickening medium if you want a more textural effect.

### Palette and equipment

- **Artist's quality thick and standard acrylics:** (1) lemon yellow, (2) yellow ochre, (3) leaf green, (4) ultramarine, (5) vermilion, (6) cobalt blue, (7) lamp black, (8) titanium white
- **Pencil:** 2B
- **Brushes:** No. 6 and No. 8 round
- **Surface:** Hahnemuhle Britannia 300gsm (140lb)

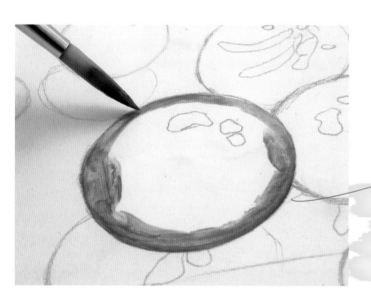

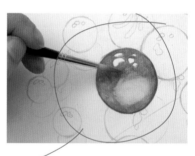

**1.** Form the edges of the green marble with a blend of leaf green, ultramarine and lemon yellow. Paint an oval of lemon yellow near the bottom of the marble and add the white highlights.

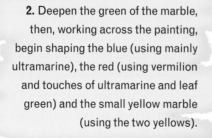

**2.** Deepen the green of the marble, then, working across the painting, begin shaping the blue (using mainly ultramarine), the red (using vermilion and touches of ultramarine and leaf green) and the small yellow marble (using the two yellows).

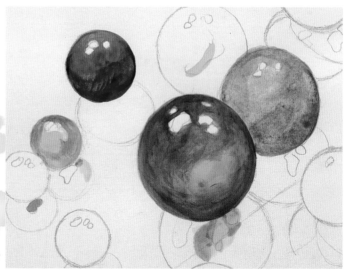

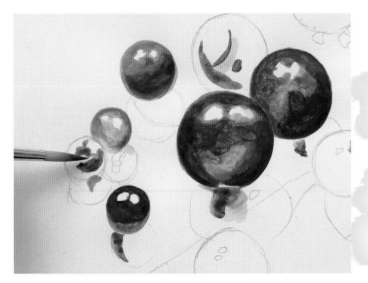

**3.** Using the No. 6 brush, work across the painting, developing the marbles and picking out shadows as you go. Notice the patterns of the glass and the shadows and try to give a rhythm to the image. The small yellow marble, for instance, has tiny touches of blue and violet, made with ultramarine and vermilion. Use some of these colours in the shadows and tints on the floor around the marbles.

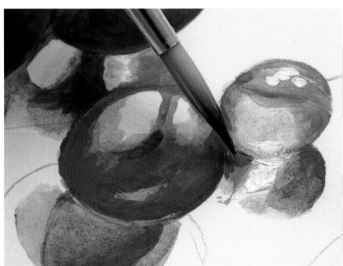

**4.** With the No. 8 brush, strengthen the shadows with deeper mixtures of ultramarine and vermilion. On the deepest shadows, apply smooth, opaque mixtures of ultramarine and vermilion and add thinner, less opaque touches of the clear colours to show where the light reflects colour through the small glass orbs on to the floor. Make sure that the marbles and shadows aren't merging into one. You can add a small rim of reflected light under a marble to lift it from its shadow, as shown on the front blue marble here.

**5.** Build up the black speckled marble with some black mixed with additions of cobalt blue and white where the highlights and shadows make it look solid. Add a light curve of white and black where the floor reflects upwards and some bright touches of vermilion to pick out the patterns on the marble. One of the advantages of acrylic is that you can paint bright or light colours over dark ones, which isn't possible in watercolour.

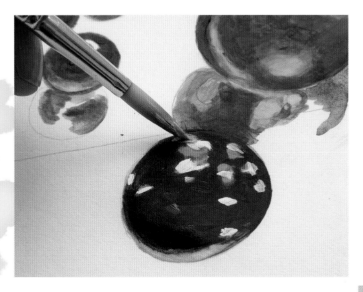

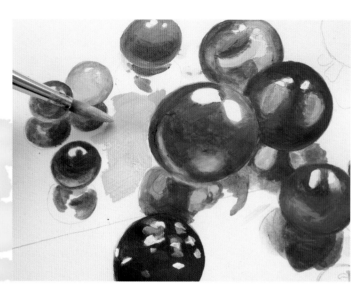

**6.** Begin painting the wood-grain floor – just the idea, no details – with white, yellow ochre and ultramarine. Use a fairly small brush to work around the marbles and follow the direction of the wood grain where possible.

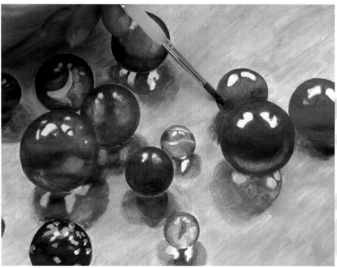

**7.** Work across the painting, deepening and rounding the edges of the marbles and adding highlights – you will need to look carefully at the photo to see where the highlights fall and their shapes and intensity, as some marbles are more opaque than others.

**8.** Pick out deep tones, shadows and other contrasts. Add some complementary colours to the shadows and some reflections from the floor and adjacent marbles. Keep the roundness of the marbles in your mind as you paint and let your brushstrokes follow the forms. Strengthen the dark shadow on the red marble – lick it right round the ball to emphasize its spherical shape. Make any other final adjustments needed to the marbles.

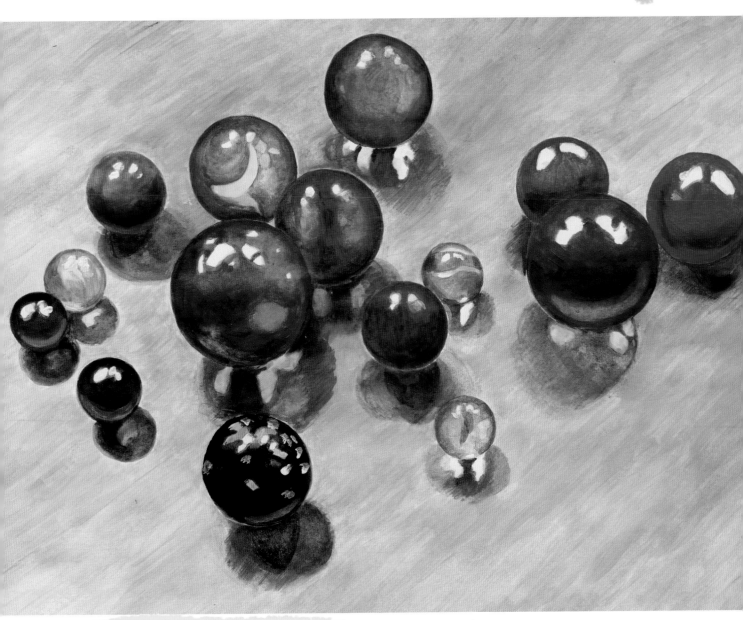

**9.** Soften any hard edges of the reflections on the floor by agitating the brush around the edges with some of the floor colour. Using a clean brush, strengthen any white highlights. In the final painting, the marbles have a sturdy three-dimensionality about them so that you feel you could almost pick them up. This is achieved by careful use of tones. Notice how these range from pure white through to a really dark version of each marble's colour.

**TIP** *Wash up well*

*Don't forget to clean your palette and brushes after use. Although acrylics dilute with water, once dry, they can be difficult if not impossible to remove – and from clothing too!*

# Buildings

Buildings can be tricky to paint at the best of times. You often need to handle both linear and aerial perspective, subtle nuances of colour in all manner of surfaces and textures, and intricate details of structures and façades.

### Trusty tripod

If you don't have a stitch facility on your camera and plan to make your own composite image, a tripod is very useful. You can position your camera on it then move it a little at a time either vertically or horizontally until you have all the shots you need. Otherwise, try to find a wall or any other support you could use instead.

Fortunately, most paintings work best when some details are left to the imagination, even when your subject is a building with some wonderful architectural features, so don't worry if you can't reproduce every piece of moulding or filigree work. As with everything else, a hint at what is there, using tones or colour to differentiate, will give a stronger image in the end than an overworked painting (unless you are reproducing a careful architectural rendering, of course).

Dramatic things can happen to a building's perspective when you take a picture of it using a wide-angle lens, yet this may be the only way you can fit the whole building into one photo. An alternative is to use the 'stitch' facility that many digital cameras have, designed for taking panoramic photographs. This can be useful for capturing landscapes, seascapes, cityscapes and buildings in general. If your camera has this facility, use it for

making unusual or exciting compositions. Or, if you want to create a panoramic view in another way, try joining two or three photos together by moving your camera along or around a scene and taking photos at each stage. With buildings, it's not always possible to take shots from too many different angles, but do what you can to angle your camera so you are at least capturing the building or buildings in different lights. Always plan your composition, but at the same time try to make the painting look effortless and enjoyable.

Because of their nature, buildings block and reflect light in different ways depending upon the weather conditions and the time of day. Sometimes this will work for you and at other times you will only have the chance to photograph buildings in dark or sombre light, not showing off their best features. When this happens, you need to train your mind to remember what interested you about the building and try to recapture that in your painting. This is when a few hastily written notes or a casual scribbled sketch can be invaluable.

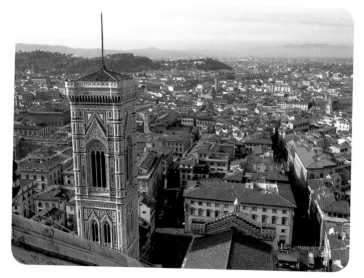

The myriad of terracotta rooftops jostling together would make a wonderful subject or an addition to a painting. Aerial or atmospheric perspective is apparent in the misty periwinkle, blue and mauve colours in the distance. Shadows from some buildings mirror shapes on others. This could be used as an exercise in perspective, colour or pattern.

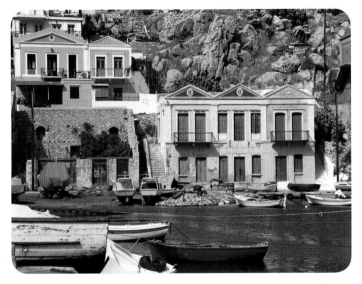

Here's a wonderful Mediterranean scene that you might capture on holiday. Consider heightening the colours of the boats to help bring them forward and knock back tones on the hillside to push it back.

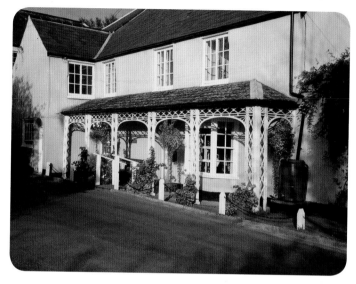

If there's a particular aspect of a building that captures your eye, like the pretty porch and flowers above, make that the focus of your picture – it isn't always necessary to try to fit the whole building in one shot.

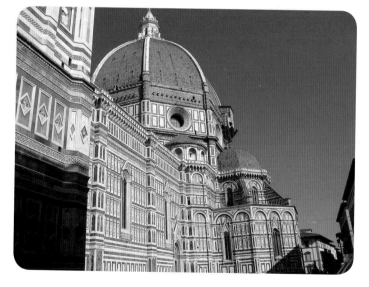

The contrasts of curves, rectilinear forms and round windows here make this view an artist's dream. To paint something as inspiring as this, you really need to take several photos of the scene from a variety of viewpoints. It could be painted directly from observation or used to form a more dynamic or Cubist-type image, using façades and wall patterns to create an angular, faceted image.

Chapels, churches and other religious buildings usually have a special dignity and often stand alone. Think of a subject like this more in terms of a portrait than anything else and aim to capture the spirit of the place.

## Country hideaway

Here we have the type of scene that cries out to be captured on paper or canvas – a beautiful house and well-kept garden, with a rustic wooden bench where we can imagine sitting to enjoy the peace and tranquillity of the rural setting. You can almost hear the bees buzzing and the birds singing.

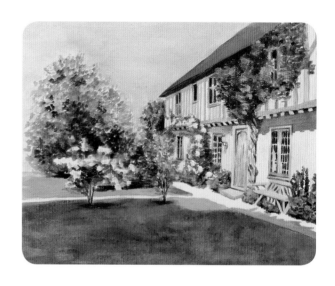

*The perspective of the house as it stretches away from us helps to convey depth. It's important to get this right in the initial sketch. Use a ruler if you need to, following the lines to the vanishing point*

I increased the saturation on the photograph to enrich the colours (see page 28) and made sure that I was happy with the brightness before printing out my reference photo.

*The pale pink roses climbing on the house front and on the bush in the centre left are a unifying factor and will help lead the eye around the picture*

*The pattern of light and shade on the grass helps to enliven a plain area*

When you draw your initial sketch, make sure that the perspective works. There is no need to add details overall, just the angles and lengths of essential lines – but pay attention to the door and windows so that you can put some details in these in the final painting.

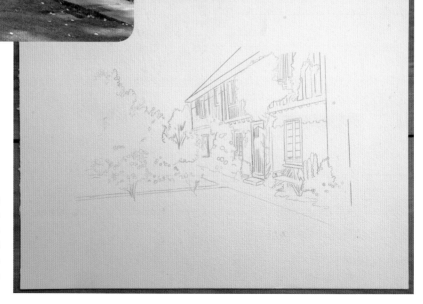

## Grey days

Painting buildings from grey-skied photos has its advantages. The shadows and highlight won't be as harshly contrasting as in brighter light and you can add your own interpretation of muted colours into walls and other aspects.

## Taking and editing photos

I used just one photograph for the painting that follows, intensifying the colours somewhat on the computer, which was all that I felt was needed. However, if you wish to experiment with images, you can scan and manipulate them in a variety of ways. For instance, you can use Photoshop or similar photo-editing software (see page 15) to manipulate a photograph, perhaps to suggest a broad brushstroke or a stippled effect. These effects are quite easy to do. All the manipulations can be carried out on the screen and the image printed off when you are happy with it. When interpreting your photographs, these effects can be used to nurture further ideas and aid your inspiration.

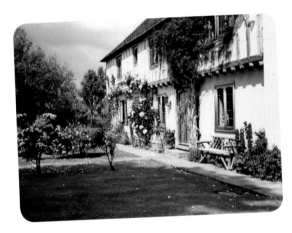

This pretty house was photographed in the afternoon when the shadows were starting to lengthen and the sun was casting a warm and welcoming light on the side of the building. The house has a lot of old-world charm and the garden was looking beautiful. Unfortunately, the photo came out looking a little flatter and greyer than I remembered.

I increased the saturation on the photograph to brighten it and then tried some of the artists' filters in Photoshop to see the effect. This is the Palette Knife filter. Notice how it has simplified the details, which can be very helpful.

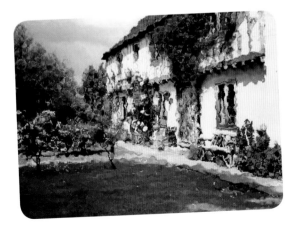

The Ocean Ripple filter in Photoshop creates an effect as if you were looking at the scene through a piece of rippled glass. This is a useful way of obscuring the details to help you see in a more impressionistic way.

This sketchy effect was created by adding the Sumi-e filter. Experiment with the effects that are possible with your particular software. These might not make your photos look better as photographs, but they will help you look at your subject in a new way, and perhaps see things you had previously missed, like the way the tones repeat across the image.

## Painting the composition

Such a scene could be captured successfully in any medium, so use whatever you feel comfortable with. For the purposes of this demonstration I chose acrylic paints, and worked on 300gsm (140lb) acrylic painting paper. I painted this image fairly rapidly, including details in some areas, but creating a more impressionistic feel overall. Start with a good, clear photo, but if you don't have that, try to picture the final result. How do you want viewers' eyes to be drawn into the image? Will you include a path? Will the building be off-centre? Where do you want the eye level to be – high or low?

### Palette and equipment

• **Artist's quality tube acrylics:** (1) yellow ochre, (2) cadmium yellow, (3) leaf green, (4) ultramarine, (5) raw sienna, (6) cadmium red, (7) permanent rose, (8) vermilion, (9) titanium white
• **Pencil:** 2B
• **Brushes:** flat (No. 4), medium round (No. 10) and small round (No. 4) synthetic brushes
• **Surface:** 300gsm (140lb) Winston and Newton Galeria acrylic paper

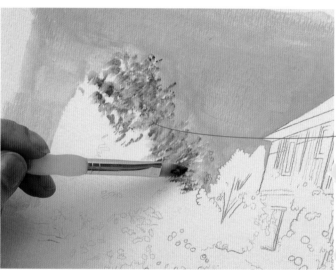

**1.** Block in the sky with a mix of ultramarine and white, using the flat brush. Create several greens from ultramarine, cadmium yellow, leaf green and yellow ochre and, with the flat brush, begin indicating some of the foliage by touching the paper with the brush, pressing slightly, then lifting and dragging in the direction of growth.

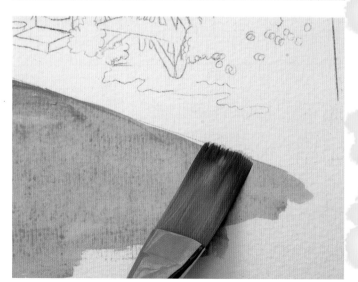

**2.** Create the grass in the same way as you painted the sky by applying the acrylic paint almost like watercolour, diluting it with plenty of water and dragging the flat brush across the area. Use a mix of ultramarine and cadmium yellow.

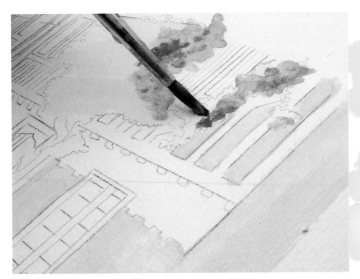

**3.** Paint the small part of roof that is showing with raw sienna and cadmium red. The pink of the house is made from white with a touch of permanent rose. Use the tip of the small round brush and work quickly, picking out all the parts of outer wall that are on show, but still not worrying about details. Begin to add the grassy areas in the front of the house with watery mixtures of cadmium yellow and leaf green and start to add some of the foliage on the side of the house. The key here is to keep the paint thin and translucent.

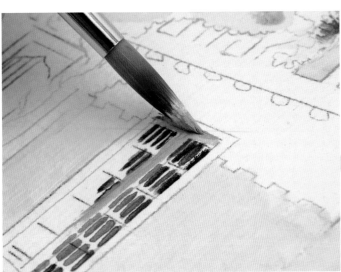

**4.** Notice where the shadows fall on the windows and create greys using various mixes of ultramarine, leaf green, yellow ochre, raw sienna and permanent rose.

**5.** Pick out the deepest shadows in tertiary colours made from blends of ultramarine, permanent rose and raw sienna. Keep checking the photo to see where the darkest shadows are and deepen the darkest areas. Work across the fascia of the house to keep the colours consistent.

**6.** Build on the foliage on the house with the tip of the medium round brush. Make sure that the colours contrast enough and that the shape of the vegetation is convincing – it's all too easy to get carried away. Keep checking the photo and stepping back to look at your painting.

**7.** Paint the wood of the house with a mixture of white, ultramarine, permanent rose and the tiniest touch of raw sienna. Build up the flowers using bright mixes of colours and contrast them with lighter and darker tones of these colours. Move from the bench to the flowers, to the door and the porch and so on, painting across the picture to keep it going, rather than concentrating on any particular area and losing the balance. Using fairly translucent mixtures (with the addition of more water), paint shadows on the ground in front of the house.

**8.** Now paint the rose bush and other plants in the front of the house. As the light is shining down on the subject, create very dark greens with ultramarine, leaf green and yellow ochre. The pink roses are made with mixes in various strengths of permanent rose and white. Work over all the flowers and plants, emphasizing tones and patterns and also adding shadows beneath bushes and trees to give them solidity.

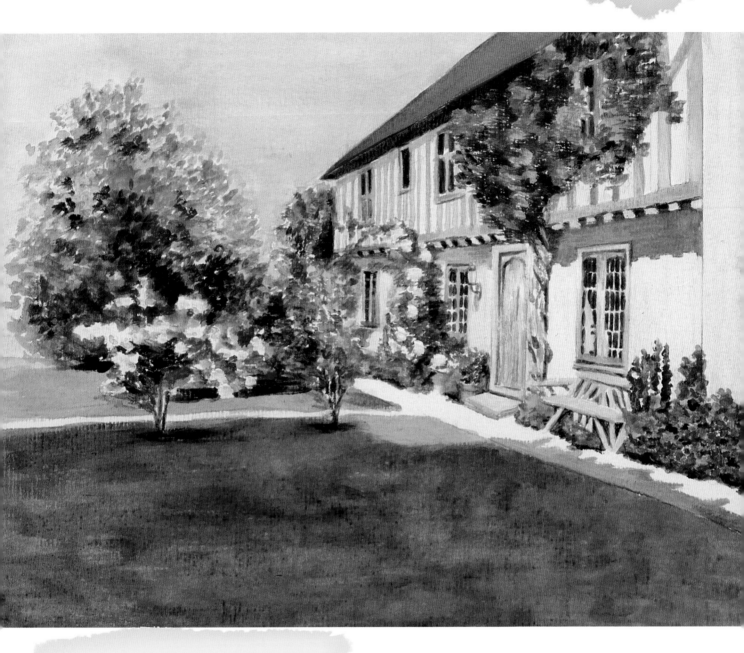

**9.** For the browns of the stems and wood, mix raw sienna, leaf green, yellow ochre and vermilion. Strengthen the darkest shadows (squint at the photo to see where the darkest tones are) and work across the painting, picking out all the brightest highlights with white paint. In the final painting, you can tell what the flowers are and recognize the type of bench, and yet if you look closely you can see that flowers and leaves are really just misty blobs of colour.

# Animals

Animals provide endless interest for an artist, with the challenges of showing movement and character and painting the texture of fur and feathers.

To understand the ways animals move and behave, you need to take photos as often as possible. A camera with automatic focusing is useful and if you can keep pointing and clicking, so much the better. Colours and tones of textures may be difficult. Mix your photos with some quick sketches and try observing the animal from several viewpoints. In this way, you'll gain valuable understanding of proportions and anatomy.

Unattractive backgrounds are often a problem with photos of animals, simply because you have to grab a picture when the opportunity presents itself. Shooting with a large aperture such as f/4 to throw the background out of focus is one way of dealing with this, or moving your position may give you an unfussy background. If need be, incorporate a different background from another photo, or simply blur some colours in the background to emphasize the animal when you are painting. Whatever your backgrounds, though, keep an eye on your proportions – it's all too easy to become carried away with the subject and paint an unconvincing background because the scale isn't right.

With a household pet you have the opportunity to take any number of photos. Set the focus to automatic and keep snapping away, perhaps adding a variety of props that can help to capture the animal's personality.

## Viewpoint

Some of the best animal photos are taken from the same level as the subject. If you look down on an animal it can seem small and frightened, and may look unfamiliar to you in the photo. If your eye level corresponds to that of the animal, you should be able to reflect its characteristic poses and movements. Obviously, this might be more difficult with an elephant or giraffe, for instance! Perspective will also be affected by viewpoint, which is another reason for choosing an eye-level view. If you take a picture of an animal from an extreme angle you can often be setting up some difficult challenges in perspective.

Sometimes you have to take the photo when the opportunity arises, as here, where the contrast of little and large was too good to miss. The background is far from ideal, but it can be replaced with the background from another photo or just left out completely. That's one of the advantages painting has over photography – I can put these dogs in a garden, on a beach or anywhere else that I think appropriate.

Try to catch your pet in a familiar pose. This is typical golden retriever – eager and ready for whatever is required. The trellis in the background here is distracting, but the soft lighting means that this dog will be easy to 'relocate' or the trellis can simply be missed out or blurred.

When you are photographing animals in a farm, park or zoo, it's not always possible to get the viewpoint you'd like. The buckets here are very distracting to the eye and the detail of the nose and hay is lost against them, but in the painting you could move them or exclude them altogether.

## The importance of lighting

Lighting is very important when it comes to creating a realistic and characterful portrait of an animal. Look out for the following:

• Does the lighting show the body shape correctly? Shadows create shape, so photos taken in late afternoon or early evening are usually good for this, with warm shadows and soft light.

• Can you see the texture of the coat? It's good to be able to see some texture, but you don't want to labour the point on the painting. Too many details detract from the tones and end up creating a contrived and flat image. You need to find a balance of enough contrast and detail to give interest and yet not too much so that you lose something of the mystery of the animal.

• Have you lost any important details in highlights or shadows? If so, you may be able to fill in the missing information using additional photos.

## Taking and editing photos

If you haven't done much animal painting before, the best place to start is with your own pet, if you have one. This way you can back up your photo references with the real thing. Choosing your pet as the subject also means that you won't need to worry about manipulating your photos on the computer too much – you can just keep shooting until you have what you want, and if your pet is amenable, you can even get it to sit in front of a pleasing background.

With wild animals you have much less control. You are unlikely to catch them while they are not moving, you will probably have little choice about viewpoint and you may not be able to get as close as you'd like. This isn't something to worry about – if your pictures are a little out of focus you can usually sharpen them up a bit on the computer, and if you are far away you can use the Crop tool to come in closer on your subject and perhaps create a really striking composition in the process.

If you get the opportunity to photograph an animal in its natural environment, you will have some really excellent references for painting. Take plenty of pictures of the animals, and also take some of the locality so that you can combine elements from different photos in the one painting if you need to.

*Crop to this area and enlarge*

Even the most basic photo program on a computer has a cropping tool. It's one of the easiest tools to use but also one of the most useful (see page 25). Here, the photo of the elephants crossing the road has been cropped in tight so that the animals fill the frame, adding drama. More of the front elephant has been cropped off to lose the sense of them walking out of the frame.

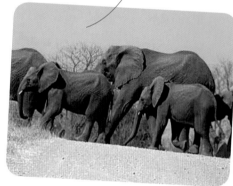

When there is a group of animals in your photo you don't need to include every one. This crop isolates the baby elephant, which would make an endearing painting. You may wish to include some of the mother elephant to show scale.

Try to sketch animals whenever and wherever you can. If you feel really hesitant about working from life, make sketches from photographs to start with. Study your subject closely to get a feel for its weight, muscularity and character as well as the more obvious visual characteristics.

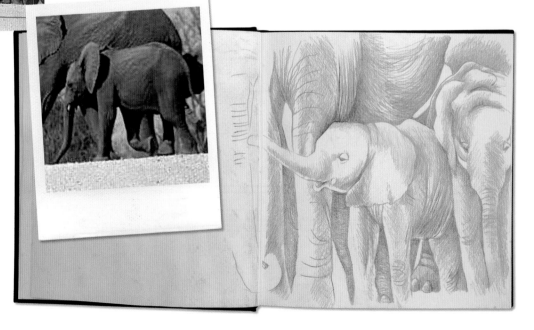

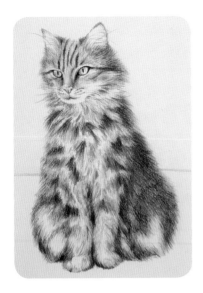

# Domestic cat

Coloured pencil work needs careful attention to detail and a great deal of patience for an effective finish. Firm pressure, several layers of colour and strong concentration are all important. The best way to create a coloured pencil image like this is to focus on the colours, tones, markings and texture. The light helps to describe the cat's form and to show the length and depth of the fur, so use this as a guide to help you place your coloured pencil marks.

*The soft lighting means that nothing is lost in deep shadow or highlight*

*It may seem that duplicating all the markings on this cat is quite an undertaking, but they have a role to play in helping to show form*

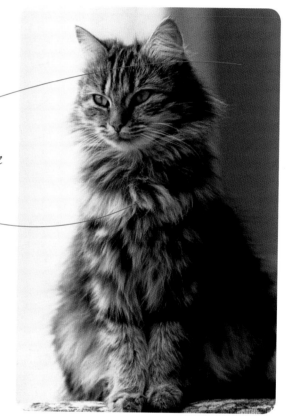

The texture of this lovely cat's fur seemed to demand a drawing medium, so I chose coloured pencils for the demonstration that follows.

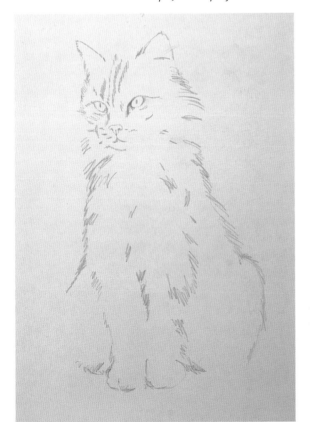

This is the initial sketch for the cat drawing. With animals – as with people – the positions of the facial features are as important as the shapes of the features themselves, so it is vital to get all these in place. You will also wish to rough in the positions of ears, paws, tail and so on. Use a light touch to draw the shape of the cat and mark in the eyes, whiskers, nose and some of the fluffy fur around the cheeks, ears and body. Keep this as light as you can and don't worry about details – you are merely giving yourself a guide at this stage.

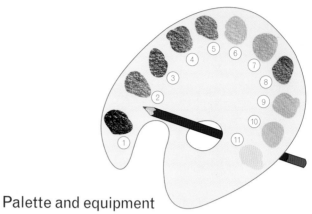

## Drawing the composition

The texture of a cat's fur is particularly suitable for rendering in coloured pencil rather than a painting medium. However, you will find that you need quite a large range of colours even for a fairly neutral subject like this because you can't mix and blend colours in the same way as, say, watercolour. Use my list of colours as a guideline only because colour names vary depending on the manufacturer. So, for instance, if you have a chocolate brown, it's probably the same as my burnt umber, while my golden brown could be the same as your brown ochre. All that matters is that you get the same general colours and tones – the cool colours are cool and the darkest tones are really deep. Do that and everything will fall into place.

## Palette and equipment
- **Coloured pencils:** (1) black, (2) warm grey, (3) burnt umber, (4) brown earth, (5) golden brown, (6) peach, (7) sepia, (8) brown black, (9) olive green, (10) light green, (11) pale brown
- **Pencil:** 2B graphite pencil
- **Eraser**
- **Surface:** 200gsm (110lb) acid-free cartridge paper

**1.** Using burnt umber, begin the delicate layering process needed to build up the impression of fur. Apply the pencil lightly and in quick, feathery strokes in the direction of fur growth. Only apply the burnt umber where you see it on the photo – don't be tempted to outline the cat, but work across the body. Start to add some golden brown on the medium tones.

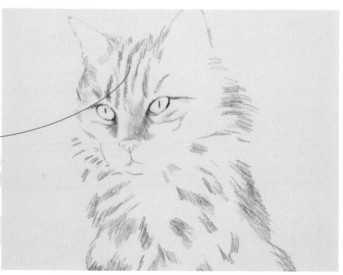

**2.** Begin building up the tabby fur pattern with light touches of black and pale brown. Fur grows in different directions all over a cat's body and getting the direction of growth right is particularly important to give the cat shape and form.

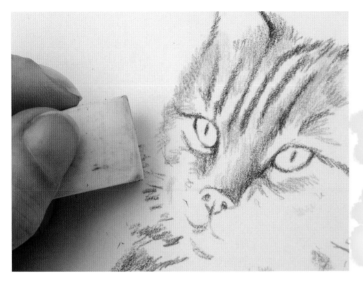

**3.** To give the impression of light shining on the fur, lift out the highlighted areas using an eraser. (If you were drawing a flat or short-haired animal, you would leave the paper untouched with colour to give the impression of shine).

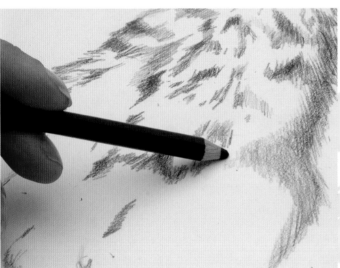

**4.** Always be aware of the tonal values – it's all too easy to become carried away with creating the texture and forget to make the animal look three-dimensional. So begin picking out the darkest areas – check with the photo where these are. These darker areas must be dark enough to contrast with the light areas.

**5.** Apply short strokes of brown black around the cat's eyes and nose, paying close attention to the markings. Cat eyes are particularly luminous. With coloured pencil this is captured by layering colours but with different lengths and directions of marks. It's worth spending time on these details. Keep your pencils sharp for this. Use the olive and light green coloured pencils to build up the light and darks, remembering to leave paper showing through for the white highlights.

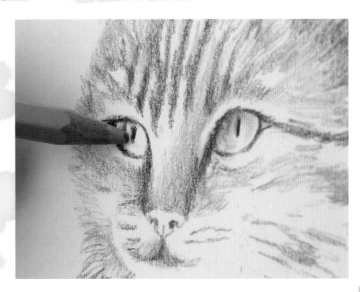

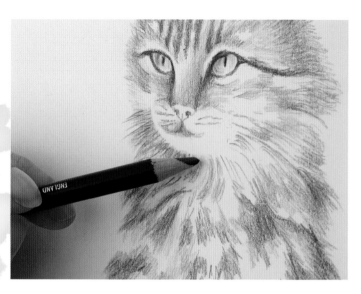

**6.** Carry on working around the cat's body, applying layers of light, medium and dark browns as you see the tones on the photo. Keep your touch light and don't feel you should cover all the paper with marks – the absence of marks will help to give the impression of light falling on the fur and add more realism to your work.

**7.** As you layer on more colour, you will find that the impression of soft fur builds. Layer light over darks and drag some colour down – the body is the fluffiest part of this cat, so it needs a covering of soft, feathery strokes. Keep your hand relaxed and move about the animal, making scribbled marks in short and longer lines. Observe how the fur occasionally flicks away from the body and do the same with the coloured pencil.

**8.** Carry on looking for the shapes within the fur and break them down into patterns of lights and darks. Never assume that you know where these are! Keep checking the photo and try to match this in your picture. Begin to work faster and almost 'wash' the lighter colours over the paper, while still applying the feathered strokes with the darker browns, such as brown earth. For deep, dark areas, increase the pressure and density of stroke. Use sepia or brown black to darken the markings where necessary.

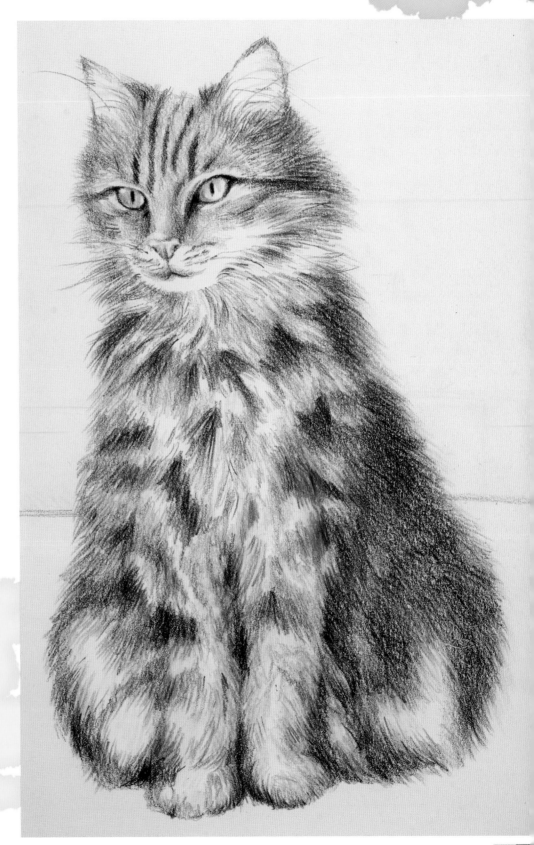

**9.** Warm grey has been added around the body to enhance tone and texture. Touches of peach were applied to the nose and ears. The final drawing has captured the form of the cat, its long, soft fur and its forceful stare. There is the merest indication of a background – the line between floor and wall. No more is needed because the subject here is the cat, not its surroundings.

# Portrait

Drawing people from life is the best way to obtain the complete view – to observe how the facial muscles work and how the individual moves and speaks, and to gather something about their character, outlook and interests.

However, if you aren't confident with your drawing skills or if your subject moves too fast, you can use a photo. If possible, study your subject in real life and ideally make sketches as well to support the information that you obtain from your photos, but if that's not possible, then you can still make a successful portrait using photos alone. Photos have other advantages too – they make it possible to capture transitory expressions, passing glances and body movements. Be aware that you have to use a certain amount of imagination and projection with photos – you need to visualize the person in the round.

**TIP** *Position is everything*

*It's not just the shape of facial features that varies from person to person, it's the position of those features too. To get a good likeness it is essential that the facial features are positioned in the right place. Your photo really helps here. If necessary you can get out your ruler to compare gaps and to check angles.*

Try to sketch people whenever you can. This is usually easiest if they are involved in some sedentary occupation such as sitting on the sofa watching television, knitting, reading or dozing in a chair. Constant practice will help you understand how to get a real likeness and it will give you more confidence too.

Try making a tonal drawing, either from life or from a photo. Concentrate on what you really see rather than what you think is there. For example, in this sketch there is no bridge to the nose – you know it is there, but when working from this angle and in this lighting, you don't actually see it.

This is an excellent shot for a portrait. The lighting is soft and natural, and therefore flattering to the children, and the bench adds a wonderful sense of scale.

Don't think of portraits only in terms of being indoors – outdoor lighting is often the most flattering and interesting. This isn't strictly a portrait but it does capture the boy in a characteristic pose. It would work well in a square format.

## The right pose

• Consider how to crop the portrait. A classic composition is head and shoulders (think of the Mona Lisa) with lighting coming from slightly to one side and from above the subject, but you can include more of the body or even show the whole figure, perhaps reclining on a sofa or reading in a chair – whatever seems appropriate to that person.

• Make sure your sitter is in a pose that looks comfortable and relaxed. Ideally the pose or setting should also say something about his or her personality.

• Make sure you are comfortable with the composition and that there is something in it that appeals to you.

• Look out for patterns and interesting shapes, which means observing the person and their surroundings objectively and as a whole. Be aware of the negative shapes of any position your sitter is in – the spaces around and between the limbs are as important as the limbs themselves.

## Clothing and fabrics

You can use the way clothing clings or falls around the body to help you show form in your painting. Notice how patterns curve and distort round the body's contours and how draped fabric falls in twists and folds. Notice also where the fabric pulls and shows tension or, perhaps in the case of a shawl, hangs gracefully from the shoulder.

It is a useful exercise to sketch draped fabrics and try to catch the form in different ways. See how few marks are needed to show the shapes and also try more complicated sketches in which you catch the nuances of tone. Look out for contrasting patterns in fabrics, hair and figure shapes.

Natural poses and happy personalities make the best portraits! Make sure your subject is warm and comfortable, and, especially with children, try to capture only the essentials.

## Taking and editing photos

If you are asked to paint a portrait, you will often be given a photo or two from which to do it. However, it's usually better to take your own photos if possible. This way you can not only get to know a bit about the sitter but you can also control the set-up to some extent.

One of the most important things to consider is the lighting; it is often best to avoid using flash because this can flatten faces and can produce harsh reflections. Think about expression and pose – how are you going to create some kind of atmosphere or 'story'? If you do get the chance to take your own photos of a subject, try to ascertain something of his or her personality. Is she outgoing? Does he play sport? Does she smile readily? Is he a conventional or serious type? Although you might not be spelling all these things out obviously, there are ways you can include something of a sitter's personality in your painting.

### Capturing a mood

A good way of painting a portrait, rather than focusing solely on likeness, is to try to capture a mood or atmosphere. If your subject has a smile tickling the edges of their mouths, emphasize the happiness factor. If they're looking thoughtful, use blues and violets to create a reflective air.

A natural pose tells viewers more about the sitter's personality than anything, but it can be difficult to capture on camera. Try chatting to your subject, while you are taking many photos. Most might be wasted, but one or two might be gems.

If your camera has a zoom lens (see page 14), you can take close-ups without making your subject feel self-conscious. A three-quarter angle on the face is usually sympathetic in terms of shapes and shadows.

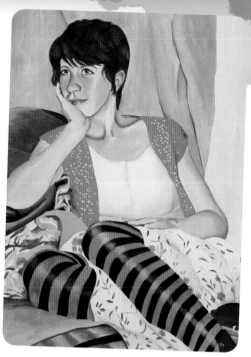

# Lady in red

A relaxed, everyday pose like the one in this painting is ideal for a portrait. A head-and-shoulders view can look rather formal, but by including more of the figure you get away from the passport-photo look. Clothing can also add to the feeling of a real personality in front of the artist – this bright, informal outfit suggests a confident, individualistic character.

The subject of this portrait looks relaxed and comfortable, with several patterns and contrasts in shapes and textures that create a vibrant and happy image. The light seems natural and clear yet it's not so direct that it bleaches out the main features.

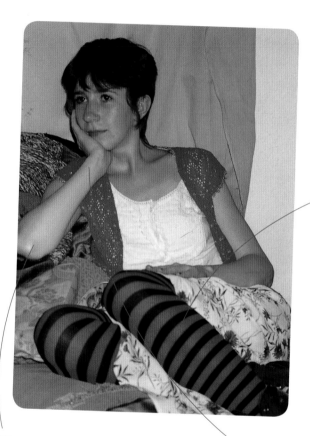

*The dynamic line of the legs draws the viewer straight into the composition*

*Think about the distribution of the model's weight. Her head is resting on her right arm so you will need to make sure that you show the support underneath or it could look as if she is about to topple over*

*The pose is relaxed, and the viewers will feel relaxed too when they see it. It is also a pose that could have been painted from life*

Carefully noting the positions of the features and the shapes that make up the image, make an initial sketch, including only the essential lines and marking on some parts that define changes in colours or tones, such as the shape of the skirt and some fold lines, the angle of the chin, neckline and hand and the lines of the hair.

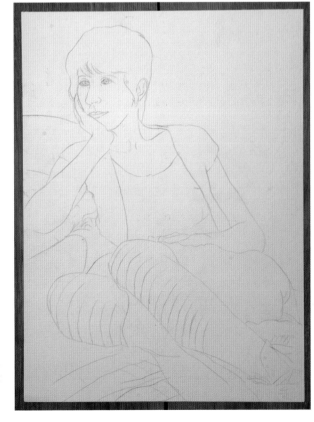

## Painting the composition

In a portrait, the hair and eyes must look especially convincing. Build up the hair with layers of short brushstrokes to indicate the direction of growth and the way it falls. When painting the eyes, always be aware of the spherical shape of the eyeball. This means that there will be curving shadows under the lids as well as bright white highlights where the light falls – not necessarily in the centre. Before you start, note the eye level – is your sitter looking down or up at you? Is the lighting strong or gentle? Tones in any colour skin always contain some blues and greens – so add a little of this in the darker areas, particularly when you're using opaque materials such as oils, acrylics or pastels.

## Palette and equipment

- **Oil paints:** (1) Naples yellow, (2) yellow ochre, (3) cadmium yellow (pale), (4) sap green, (5) ultramarine, (6) cadmium red (light), (7) alizarin crimson, (8) raw sienna, (9) raw umber, (10) burnt umber, (11) lamp black, (12) titanium white
- **Brushes:** Small (No. 4) and medium (No. 6) round synthetic brushes
- **Pencil:** 2B graphite pencil
- **Surface:** canvas paper

**1.** Mix up the palest skin tones, using Naples yellow, white and a small amount of raw sienna, and then begin painting in long, smooth strokes on the lightest areas of skin. Move across the painting, applying the lightest skin tones where you see them to keep the balance.

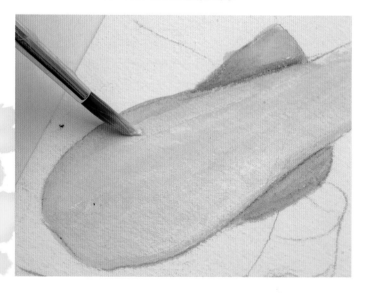

**2.** Create the medium tones with raw umber, white and a speck of ultramarine. Paint smoothly around the arms, neck, chest and face to establish the midtones. Keep an eye on the photo to see where the light falls and where the light, dark, cool and warm colours are.

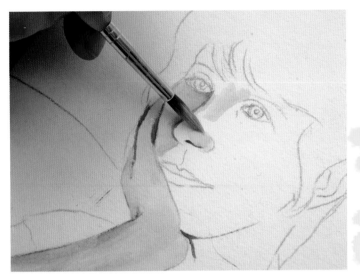

**3.** Now build up some darker and warmer tones on the skin. Make a mix of raw umber, burnt umber and a touch of sap green and work over and around the portrait, painting the deeper areas with the point of the No. 4 brush. Keep checking that you are maintaining the balance across the painting.

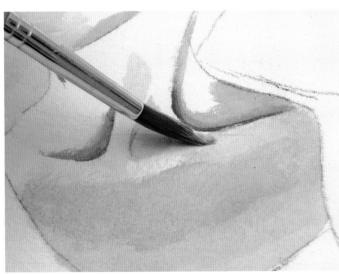

**4.** Apply the deepest tones using a mix of burnt umber, raw umber and a touch of ultramarine. Pick out areas around the chin, throat and arms with the point of the medium round brush. Add yellow ochre or raw umber to any of the skin tones where you need to create warmth. Carry on building up the skin colours and tones, moving around and across the portrait, ensuring that you keep everything balanced and bearing in mind where the light is coming from. Soften any lines that may have become too harsh, such as under the jawline.

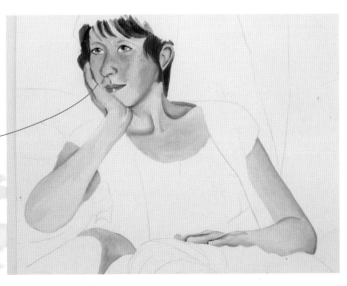

**5.** Shape the mouth with a mix of cadmium red (light), sap green, alizarin crimson and a touch of yellow ochre. Build on the hair with sketchy strokes, using colour to show highlights, movement and texture.

**6.** Continue to build up the hair and skin tones. Using white, add highlights to the hair, applying the paint fairly dry and agitating the dark browns around the white marks in order to soften them.

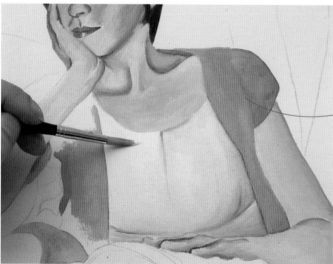

**7.** Paint the red cardigan using mainly cadmium red light and alizarin crimson. For the blouse, use white, ultramarine and a speck of black. Use the tip of the medium round (No. 6) brush to apply white dots randomly over the cardigan to give the impression of lace.

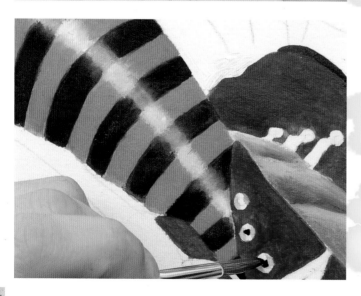

**8.** Create the cloth in the background by marking in the darkest tones first and then adding the medium and light values. The tights take time! Use a mix of cadmium red light and alizarin crimson, plus black and white, following the shapes of the stripes around and up the leg. Form the shape of the boots with a mix of burnt umber, ultramarine and alizarin crimson. Pick out the laces in white and highlight the metal with rims of yellow and white.

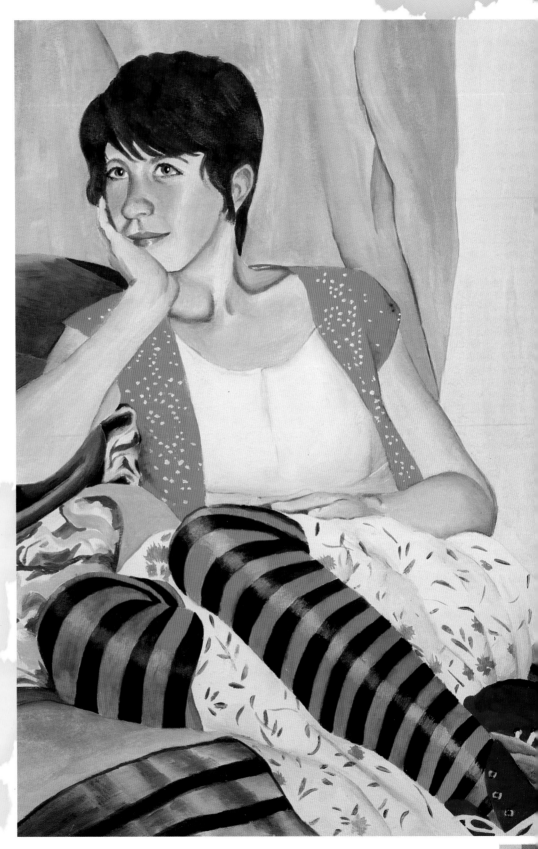

**9.** To paint the skirt pattern, pick out the flowers with the tip of the medium brush. Create soft tones and shadows in the skirt with ultramarine, white and a speck of black. Work up the green cloth and the cushion using darks, lights and different shapes. Finally, check that your tones are strong and contrasting and your textures are convincing, with soft highlights for soft textures and sharp highlights for hard ones.

## Acknowledgments

I would like to thank the following, who were all extremely helpful in the production of this book. First, to everyone who has given me photos to paint from, especially John, Dawn, Katie, Mum, David and David! Then of course to everyone at David & Charles: Freya Dangerfield, Emily Rae, Betsy Hosegood, Demelza Hookway, Sarah Underhill, Martin Smith, Sue Cleave and Bethany Dymond; thank you for your enthusiasm, patience, hard work and great planning, editing and designing. Thanks as well to Kim Sayer for his brilliant photography – and warm hospitality!

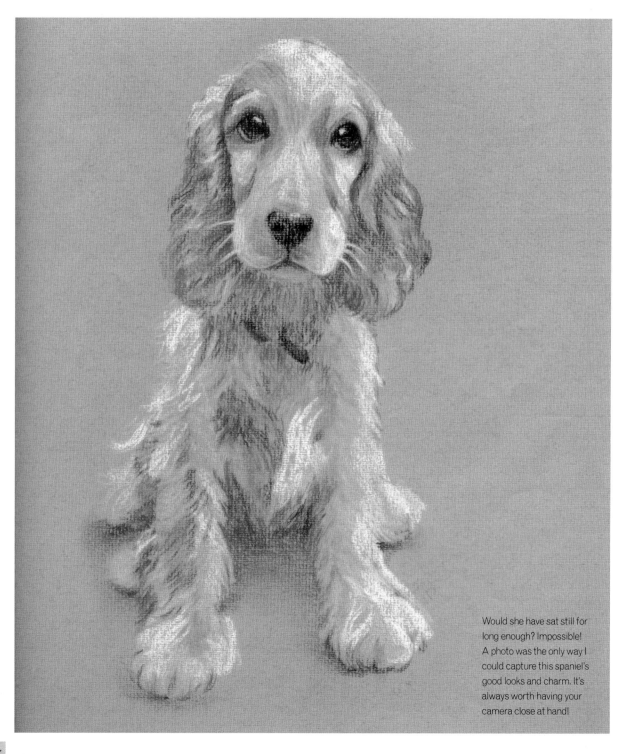

Would she have sat still for long enough? Impossible! A photo was the only way I could capture this spaniel's good looks and charm. It's always worth having your camera close at hand!

## About the author

**Susie Hodge** has an MA in the History of Art by Research from Birkbeck, University of London. She is the author of more than fifty books, mainly on practical art and art history, and is currently writing books on modern art and ancient Egyptian art. She contributes to various magazines and writes booklets and web resources for museums and art galleries, including the Tate, Royal Academy, Museum of London and V&A. Previously a copywriter at Saatchi & Saatchi and JWT, she has since taught art to children and adults for several years. She exhibits her own work in the UK and abroad as well as giving talks, and runs workshops and seminars for various institutions. She is a governor at the University of London and a Fellow of the Royal Society of Arts.

## Picture credits

# Index